CUTE FANTASY ART CLASS
MYSTICAL ANIME BESTIES
Learn to Draw
OVER **50** CHARMING CHARACTERS

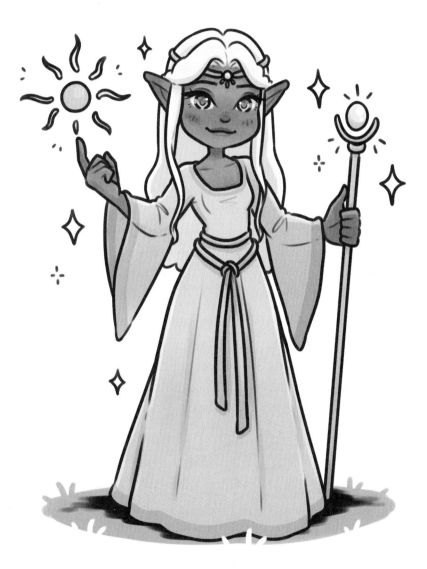

NAOMI LORD

ROCK POINT

CONTENTS

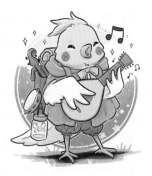

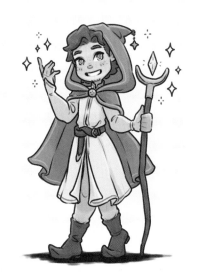

THE MOONLIT MOUNTAINS * 61

THE WILD HAMLET * 83

BONUS CHARACTER FAMILIARS * 119

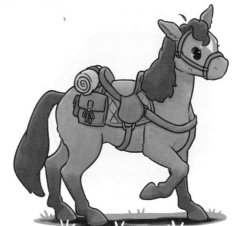

HIYA!

My name is Naomi, but you might have seen me around online as @naomi_lord or @naomilordart. I'm a self-taught artist from the United Kingdom and I have always loved to draw. Around 2017, I began to take my art more seriously and started to draw a lot of chibi (a Japanese word for "small and cute") versions of characters, animals, and creatures. Since then, I've continued to develop my work and explore my own anime-inspired style.

Over the years I have posted a lot of my art online and have gained a following of lovely supporters. They have been huge motivators for me to keep drawing and developing my work. Hopefully this book will do the same for any aspiring artists out there. If you want to learn how to draw some of your own cute fantasy characters, you've come to the right place!

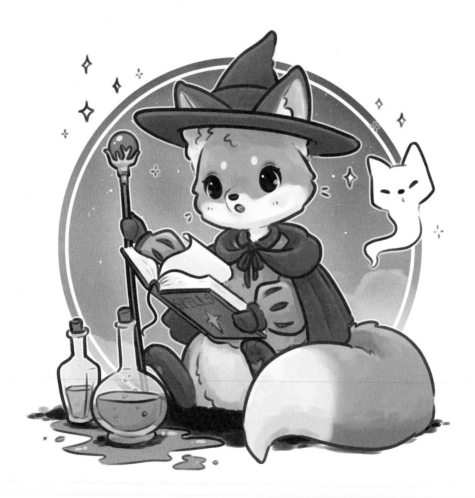

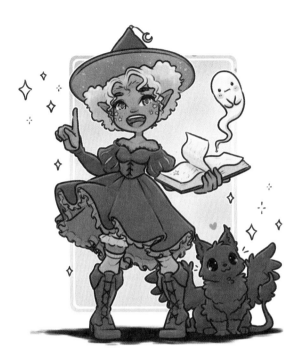

WHAT IS ANIME?

Anime is the name for Japanese animations, but over the years it has also come to refer to a specific style of art. Anime characters are known for their expressive faces and exaggerated features, with many subgenres to dive into. One, for example, you will notice in this book, as most of the characters here are drawn in a kawaii (Japanese for cute) or chibi-like style. There are no set rules or limitations when it comes to art styles, so you should feel free to try it out for yourself, then use your creative instincts to make it your own! For me, I usually stick with big eyes, pastel colors, and lots of sparkles.

HOW TO USE THIS BOOK

First, I will share helpful information and advice to get you going, including recommended tools and techniques for drawing and coloring. A Character Key will introduce you to the characters that you will learn how to draw in this art class. With fifty-one step-by-step tutorials, this book is divided into five chapters: The Enchanted City, The Ancient Forest, The Moonlit Mountains, The Wild Hamlet, and a bonus chapter of Character Familiars so you can give your character their very own creature companion for their adventures! Each chapter has lessons that go from simple to more complex. The tutorials are beginner-friendly, with room for a challenge for those who desire it. Feel free to customize your character as you go!

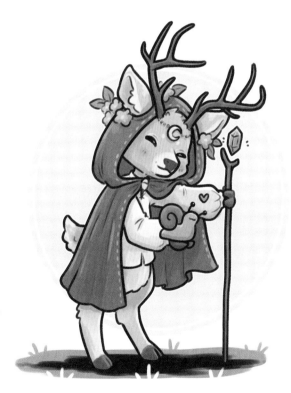

TOOLS

To create these lessons, I used a digital tablet and the Clip Studio Paint program for Windows PC, but you can use any medium you like or whatever you have on hand. For those who are interested in learning about what I use, here are a few suggestions.

Traditional

Traditional mediums are things like pencils, pens, and paints. If you are using traditional tools, I recommend working with a pencil and scrap paper to practice and warm up before starting on the final drawing. Once you are comfortable, start the final illustration on plain paper, lightly draw the new sketch with pencil, and use a black ink pen to define the line art. When the ink is completely dry, gently erase the sketch underneath for a clean look. You can purchase a light box, too, which allows you to trace your sketch onto a fresh sheet of paper.

Digital

Digital art means working on tablets that connect to a desktop computer or laptop, or standalones, like an iPad. Digital gives you a lot more flexibility and control thanks to the Undo tool that's at your disposal. You should also take advantage of the Layering tool found in most software, which keeps the sketch, line art, and coloring layers separated. In the tutorials, you'll see I use the Layering tool to spotlight each new line made to the drawing. Just make sure your layers are always separated—there's nothing worse than spending hours working only to realize your line art is on the sketch layer (ugh!). When it comes to software, there is Adobe Photoshop and PaintTool SAI. For iPads, I recommend Procreate or Clip Studio Paint. If available, turn on the

pen-pressure setting. You can vary the line weight and make your line art look far more dynamic by adjusting the pen pressure. The example on the right shows the difference between no pen-pressure lines with the same thickness all over (left images) compared to lines that flow smoothly from soft and thin to heavy and thick (right images).

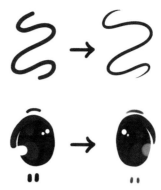

DRAWING YOUR FANTASY CHARACTERS

For those who want or need them, in this section you'll find tips and tricks for drawing and customizing your fantasy characters.

Facial Expressions

My tutorials feature a specific face in each lesson, but you can mix them up with those from other lessons or create your own. A unique expression can bring a lot of life and feeling to an illustration, while different facial features like eye shapes can really distinguish your characters from one another. The main thing is to have fun and see what you can come up with. Here are a few examples of different expressions!

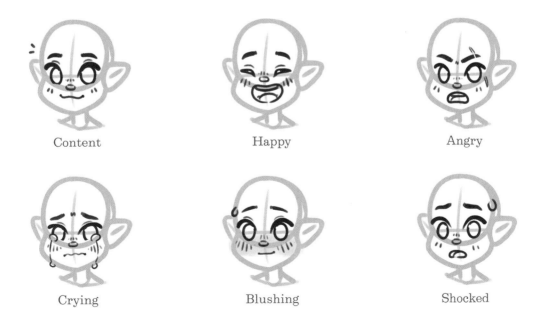

Content

Happy

Angry

Crying

Blushing

Shocked

Hair

Feel free to customize your characters' hairstyles in any way you like. You can swap the ones I used between characters or create your unique hairstyle! Long, short, side-shaved, up-do, curly, straight—you've got countless options! See below for a few different hairstyles to give you some inspiration. Just be sure to add any customizations in the sketch stage before you start using an ink liner on the final image.

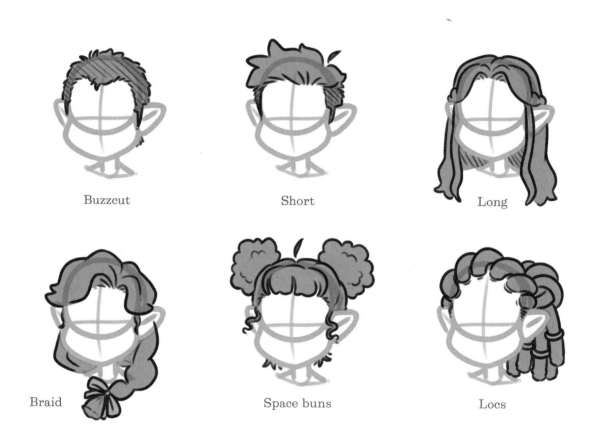

Buzzcut Short Long

Braid Space buns Locs

Body and Posing

It's always a great idea to vary the body shapes of your characters, as this can really make them unique from one another. It's also another way to show the personality of your character. Try changing up the angles to make them dynamic and alive on the page. You can also make them do something like casting a spell or holding up a sword!

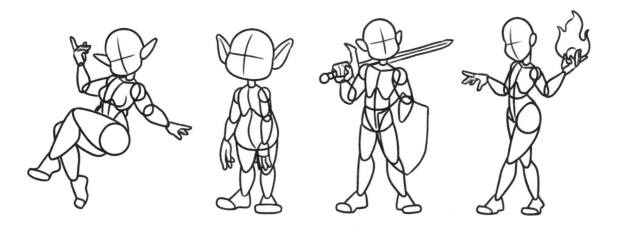

Outfits and Accessories

A great way to show a character's personality is through their clothing. Want them to seem a little more mysterious? Give them a hooded cloak. Are they heading into battle? Give them some armor. Fantasy characters must have their accessories: swords, staffs, axes, magical tomes, satchels, and more!

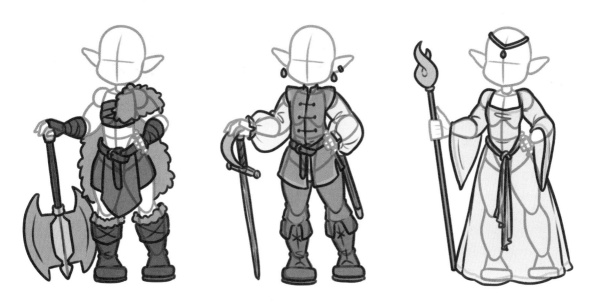

ADDING COLOR

The tutorials in this book focus more on the drawing than the coloring techniques. However, one of the easiest ways to enhance your art is by adding color. As these are fantasy characters, there are no right or wrong colors. You can stick with "natural" colors for a more grounded look, but there's nothing stopping you from making an elf green-skinned or a fairy rainbow-skinned. It's fantasy, so have fun with it!

Traditional

Below you will find a quick step-by-step of coloring through traditional mediums.

1. Start with the lightest areas; they're more forgiving if you make a mistake, and easier to blend out. Place highlights where the light hits the figure from above.

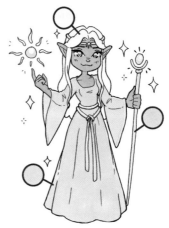

2. Fill in the main colors. Blend lightly into the highlights for a smooth transition. Be really careful not to color over any white patches (like the whites of the eyes in the example)!

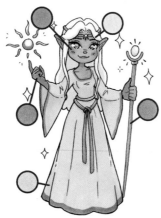

3. Add the shadows, blending them into the main colors. The shadows should be located opposite to the position of the light, usually along the bottom of the character's features.

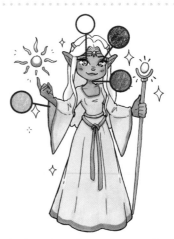

4. Add the final touches. Use a white pen for the highlights in the eyes. If you're using something like alcohol markers or watercolors, you can use colored pencils to add a bit of extra shading for dimension.

Digital

If you want to go digital, here's a step-by-step of how I color my digital illustrations.

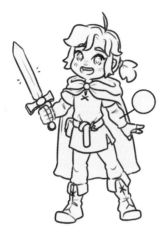

1. After you complete your line art, add a new layer underneath with the base color (the color that features most prominently on your character).

2. On top of the base color, add flat colors to all the different features.

3. Add small color details like darker areas in the eyes to define the pupils, pink on the cheeks for blush, and gold along the edge of the cape.

4. Add another layer on top for shadows. Shade the lower areas, such as below the head, the back, and so on. In most software you can add more shadows using the Multiply Layer setting at a lower opacity.

5. Add one more layer on top for highlights. The light comes from above, so your highlights should be on the top parts of your character.

CHARACTER KEY

The Enchanted City

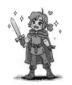

Adventurer

Their epic trials and tribulations are stories that stand the test of time.

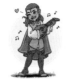

Bard

Listen closely to the lyrics of their songs, for they tell of both victorious and defeated heroes.

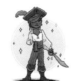

Pirate

These characters know their way at sea no matter the weather conditions.

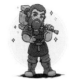

Dwarf

While small, their craftmanship and skills are mighty.

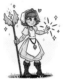

Healer

Keeping them nearby may determine the outcome of any adventure.

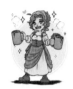

Tavern Keeper

Their establishment is the place where many travelers feel most at home.

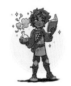

Alchemist

The science they conduct creates rare and incredible objects.

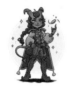

Thief

Speed and cunning are their greatest skills.

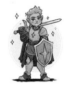

Knight

Protectors of the royal palace are loyal and stoic.

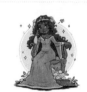

Princess

Her title and ambitions are her mightiest tools.

The Ancient Forest

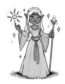

Light Elf

They are at their strongest during the daytime.

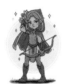

Forest Elf

They speak the words of the trees and soil.

Fairy

These powerful beings can be friend or foe.

Druid

These ancient beings have knowledge that spans millennia.

Fire Elemental

A magic wielder with a quickly rising temper.

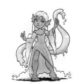

Water Elemental

When near a body of water, call on these magic wielders.

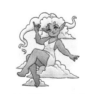

Air Elemental

An ever-present magic wielder often overlooked.

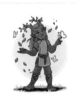

Earth Elemental

A magic wielder who has a deep connection with Mother Nature.

The Moonlit Mountains

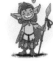
Goblin
These creatures are clever beings during both day and night.

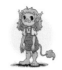
Troll
A nocturnal creature that turns to stone during the daytime.

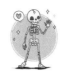
Skeleton
A reincarnated being that's reborn through necromancy.

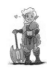
Orc
A great fighter with remarkable strength and courage.

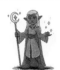
Dark Elf
A magician who studies astrology.

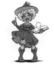
Witch
A magical being who must choose good or evil.

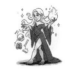
Necromancer
A mysterious creature with an indefinite lifespan.

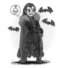
Vampire
A reanimated being with a craving for blood.

The Wild Hamlet

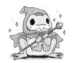
Charmer
A magical frog with the cutest intentions.

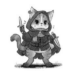
Bandit
A quick-thinking, fleet-footed cat.

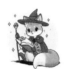
Enchanter
A talented fox who can enchant almost anything.

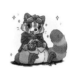
Architect
A raccoon bursting with inventions.

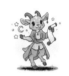
Fortune Teller
A goat with a strong intuition.

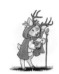
Warlock
A deer with the magic of an earth elemental.

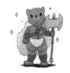
Warrior
A fearless and reliable bear.

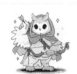
Archer
An owl sharpshooter.

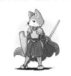
Legionnaire
A dedicated wolf with a bit of a temper.

Sorcerer
A former necromancer's crow with magic of its own.

Guardian
A slightly overzealous lion who means well.

Magician
A dragon scholar of fire magic.

Bonus Character Familiars

Frog
A leaping amphibian with sticky feet.

Snake
A sneaky reptile with venomous fangs.

Cat
A cunning, cuddly companion.

Owl
A nocturnal bird of prey with great eyesight.

Raven
An intelligent bird perfect for stealth missions.

Fox
A clever companion.

Bear
A large steed and fierce companion.

Dog
A loyal familiar with a smart nose.

Horse
A companion made for speed and long travels.

Dragon
A formidable flying serpent.

Griffin
An intimidating mix of an eagle and a lion.

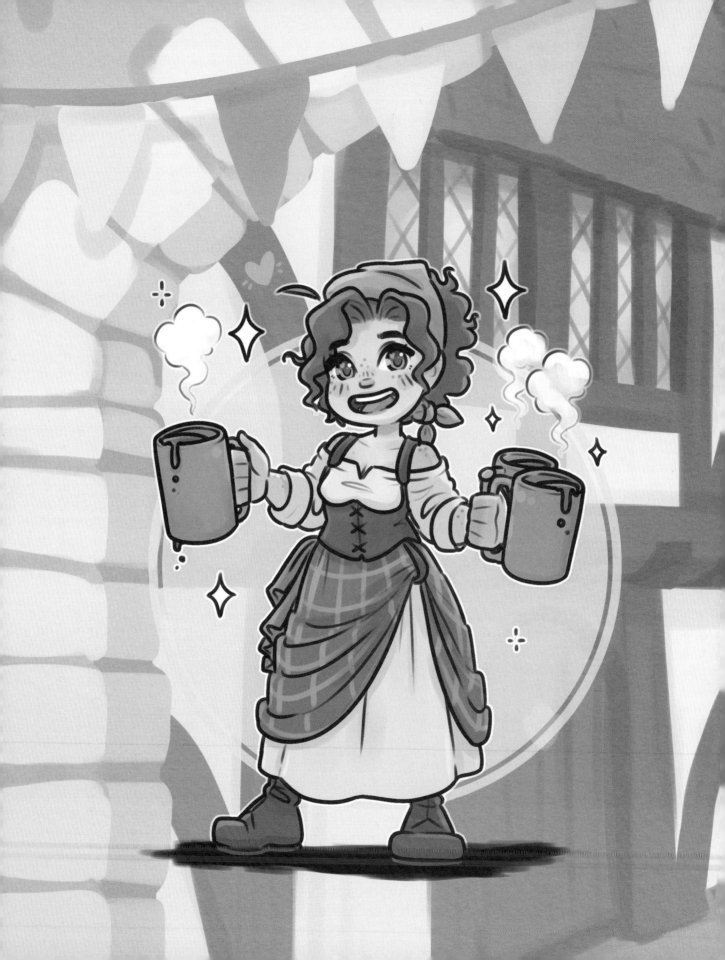

THE ENCHANTED CITY

ADVENTURER

An adventurer's destiny is to pick up a sword and head out on a great quest through The Enchanted City. This adventurer is hoping to find ancient treasure or lifelong friends, but they must first save the land from evil. Let their journey commence!

1. Sketch a round shape for the head and add a plus sign (+) guideline for the face. Draw a small oval ear and a small U under the head for the neck.

2. Draw a soft W-shaped upper body with a long, curved guideline down the middle.

3. For the lower body, sketch a rectangle with a trapezoid under it. Divide the trapezoid into three smaller triangles with two diagonal lines for the hips.

4. Under the hips, sketch two long, thin Us for the thighs. Then draw pointier Us for the lower legs. Draw the feet in two sections of a triangle and a rectangle.

5. Sketch a circle and a partial circle for the shoulders, then add the arms with a U and teardrop shape. Angle the arms so they're lifted off the body.

6. For the left hand, draw a fist with a straight line passing through. For the right hand, draw a triangle palm with some stretched-out fingers.

7. Sketch the hair with fluffy bangs and a low ponytail on the right side. Outline the neck.

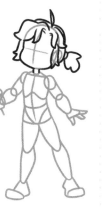

8. Draw a hood wrapped around the shoulders with a button and wavy lines for the creases. Add a rectangle cape behind the body connected to the hood.

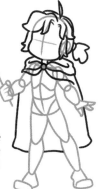

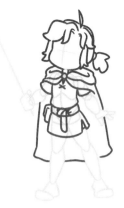

9. Draw a short-sleeved tunic with a split at the thigh. Add the belt with a looping knot. At the left hip, draw a little rectangle shape for a pouch.

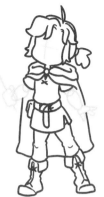

10. Draw boots that come halfway up the lower leg. Add some folded fabric at the top and a line down the middle. Sketch the pants around the shape of the leg.

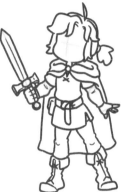
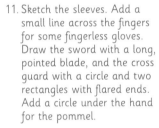

11. Sketch the sleeves. Add a small line across the fingers for some fingerless gloves. Draw the sword with a long, pointed blade, and the cross guard with a circle and two rectangles with flared ends. Add a circle under the hand for the pommel.

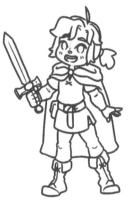

12. Add the eyes with an oval and a curved line around the top. Then add the eyebrows, nose, and smiling mouth. Add curves for the teeth and tongue and little dashes of blush on the nose and cheeks.

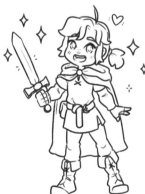

13. Neatly draw the line art over the sketch, then gently erase the sketch underneath. Add some highlights and hearts to the eyes and sparkles around the character if you'd like.

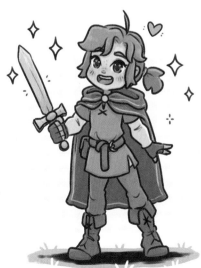

14. Lastly, add color! I went with a simple teal and neutral color palette, using teal for the shirt, a darker teal for the cape, and brown for the belt, gloves, pants, and boots. I added accents of gold on the cape and for the cross guard of the sword. Finally, I used a bright blue for the sword's gemstone.

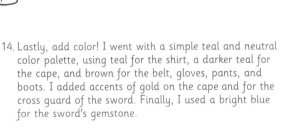

BARD

The greatest song material a bard can find is during a quest. But in between their adventures, you can most often find them frequenting the local tavern or playing in the town square.

 1. Sketch a round shape for the head and add a plus sign guideline. Draw a small teardrop on each side for the ears and a small U neck.

 2. Draw a soft W-shaped upper body with a long, curved guideline down the middle.

 3. For the lower body, sketch a rectangle. Then draw a triangle pointed down with two smaller triangles on either side for the hips.

4. Under the hips, sketch two long, thin Us for the thighs. Draw pointier Us for the lower legs. Then add the feet in two sections of a triangle and a rectangle. Make a slight arch in the bottom of the left foot.

5. In the middle of the body, draw a lute with a teardrop-shaped body, a rectangle neck, and a triangular end. Sketch circles for the shoulders, then add the arms with a U and teardrop shape pointed to the right. The right arm will be obscured behind the lute.

 6. For the hands, sketch the left one flat against the body of the lute and the right one curved around the neck.

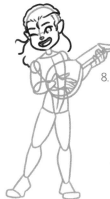 7. Add an eye with a circle and a curved line around the top. Make the left eye winking with a curved line. Draw the eyebrows, nose, and smiling mouth. Add lines for the teeth and tongue.

8. Start the hair so that it's flat on top and draping down the back. Make the sides shaved with faint dashes.

9. For the top, add a collar and pointed shoulder pads. Leave a space at the top of the shoulders for a cape. Draw loose sleeves with wide cuffs at the wrists and sketch over the hands.

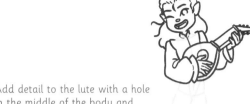

10. Add detail to the lute with a hole in the middle of the body and tuning pegs at the top.

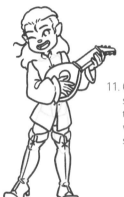

11. Complete the doublet with some buttons and a split at the bottom. Add the tall boots with a fold at the top and a small heel.

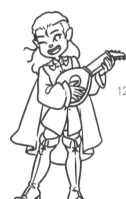

12. At the top of the shoulders, draw two small heart-shaped clasps for the cape. Then draw a flowing cape behind the body.

13. Neatly draw the line art over the sketch, then gently erase the sketch underneath. Add little details like earrings and the strings of the lute (use a ruler to keep the lines straight). Add musical notes and a heart if you'd like.

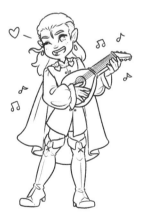

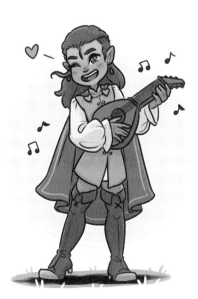

14. Finally, add color! I chose a soft pink and purple color palette, varying the shades for the doublet, cape, and hair. I used brown for the lute and boots, and finished with a few touches of gold for the cape clasps and trim, and for the boot details.

PIRATE

A pirate's life is on the ocean, hunting treasure—sometimes with luck—and maybe entering a few battles with sea monsters. When they're not on a boat, you may run into them at the city's harbor, restocking the ship and sharing the tales of long-lost lands they've yet to find.

 1. Sketch a round shape for the head and add a plus sign guideline. Draw two small ovals for the ears and a small U for the neck.

2. Draw a soft W-shaped upper body with a long, curved guideline down the middle.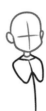

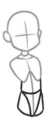 3. For the lower body, sketch a rectangle. Then draw a triangle pointed down with two smaller triangles on either side for the hips.

 4. Under the hips, sketch two long, thin Us for the thighs. Draw pointier Us for the lower legs. Then add the feet in two sections of a triangle and a rectangle.

5. Sketch circles for the shoulders, then add the right arm with a U and teardrop shape. For the left arm, only add the upper arm.

 6. Sketch the right hand holding a thin cylinder for the handle of the sword.

7. Draw the shirt with a wide V neck and a collar. Add a scarf wrapped around the waist with lines to show the creases. For the right arm, draw a wide sleeve that cinches at the wrist. For the left arm, draw the fabric folded at the elbow with a button.

8. Draw slim pants and boots with wide tops. Make the pants tuck into the boots with some creases.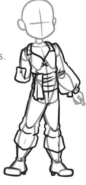

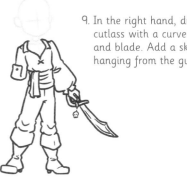

9. In the right hand, draw the cutlass with a curved guard and blade. Add a skull charm hanging from the guard.

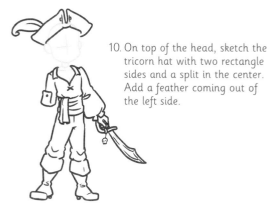

10. On top of the head, sketch the tricorn hat with two rectangle sides and a split in the center. Add a feather coming out of the left side.

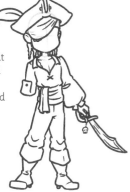

11. Draw a scarf draped in front of the left eye and wrapped around the head. Sketch some braids behind the head with wavy lines. Add some scars under the eyepatch and on the left shoulder.

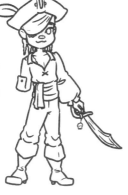

12. Add the right eye with a circle and a curved line around the top. Draw an eyebrow, nose, and a flat W shape for the mouth.

13. Neatly draw the line art over the sketch, then gently erase the sketch underneath. Add some small earrings, facial hair, eye highlights, and sparkles around the character if you'd like.

14. Time to add color! I chose some classic pirate-y colors with a simple white shirt and black boots and hat. I added pops of green for the pants and feather and red for the scarves. For the scars, I used pink.

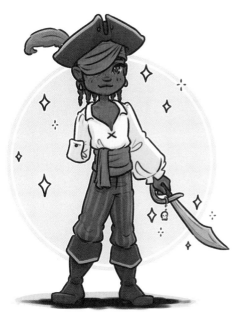

DWARF

Dwarves are highly skilled blacksmiths, taught in the caves of the mountains by knowledge passed down from their ancestors. The Enchanted City is lucky to be the host of this dwarf, who is prepared to show them what proper metalwork really looks like.

1. Sketch a round shape for the head and add a plus sign guideline for the face. Draw two small ovals for the ears and a small U neck.

2. Draw a soft W-shaped upper body with a long, curved guideline down the middle.

3. For the lower body, sketch a rectangle with a trapezoid under it. Divide the trapezoid into three smaller triangles with two curved, diagonal lines for the hips.

4. Under the hips, sketch two long, thin Us for the thighs. Draw pointier Us for the lower legs. Then add the feet in two sections of a triangle and a rectangle.

5. Sketch circles for the shoulders, then add the arms with a U and teardrop shape. Angle the right arm upward and the left arm toward the body.

6. Sketch the left hand resting on the hip and the right hand in a fist. Make the hands proportionally larger than the body.

7. Add a large, rectangular hammer with a cylinder stick going through the right hand. It will be resting on the right shoulder with part of it behind the head, but it helps to draw the whole shape first then erase it later.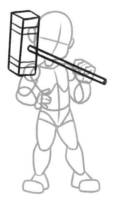

8. Add the eyes with a circle and a curved line around the top. Add thick eyebrows. Draw a small oval nose. Then sketch the moustache and the beard with three sections tied and hanging from the chin. Be sure to make some tufts of hair around the mouth.

9. Sketch the hair pulled back and tied into a small bun. Make a tuft of hair hang below the bun. Connect the hairline to the beard.

10. Draw the sleeves of the shirt folded just above the elbow. Add the outline of the arms and hands.

11. Add an apron with a front pocket. Sketch a belt knotted at the middle.

12. Add the pants and boots with a folded top. Add some creases where the pants tuck into the boots and at the ankle.

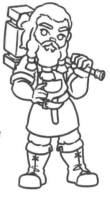

13. Draw the head of the hammer divided into three sections: the rectangle center and two square ends. Then add a little metal piece at the end of the handle.

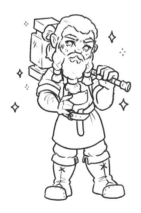

14. Neatly draw the line art over the sketch, then gently erase the sketch underneath. Add a few scuff marks on the face and hammer and dashes on the arms for hair. Add some highlights and hearts to the eyes and sparkles around the character if you'd like.

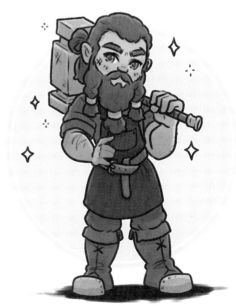

15. Finally, add color! I used an earthy palette, using brick red for the shirt, dark gray for the apron, and different hues of brown for the hair, belt, and boots. I added touches of light gray for the hammer, hair ties, and steel toes of the boots. For a pop of color, I made the eyes a bright blue.

HEALER

Healers are extremely valuable to The Enchanted City. This healer runs a small hospital on the outskirts of the city, using magic and herbs to heal the sick and injured. But on occasion she'll join an adventuring party on a quest to make sure they all get back in one piece.

1. Sketch a round shape for the head and add a plus sign guideline on the right side. Draw a small teardrop for the ear and add a small U for the neck.

2. Draw a soft W-shaped upper body with a long, curved guideline down the middle.

3. For the lower body, sketch a rectangle. Then draw a triangle pointed down with two smaller upright triangles on either side for the hips.

4. Under the hips, sketch two long, thin Us for the thighs. Draw pointier Us for the lower legs. Then add the feet in two sections of a triangle and a rectangle. Make a slight arch in the bottom of the right foot.

5. Sketch circles for the shoulders, then add the arms with a U and teardrop shape. Angle the arms so they're lifted off the body.

6. Sketch the left hand in a fist with a staff with two wings at the top. Make the right hand raised with some light rays around it.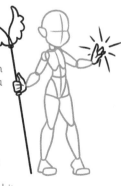

7. Add the eyes with a circle and a curved line around the top. Draw the eyebrows, nose, and a flat W shape for the mouth.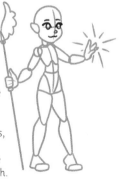

8. Draw a headdress with a crown-like top and two pieces of fabric hanging from the sides.

9. Sketch the hair as a short bob with bangs and outline the ear.

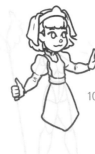

10. Add the collar and sleeves of the top with puffed shoulders, then outline the hands. Add an apron with a tie around the waist and ending in a point at the knees.

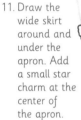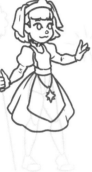

11. Draw the wide skirt around and under the apron. Add a small star charm at the center of the apron.

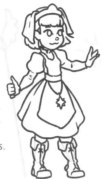

12. Sketch the boots with a fold at the top and a line down the middle for the laces.

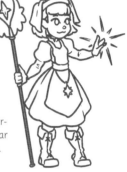

13. Add more detail to the light rays and the staff, with a four-pointed star at the top.

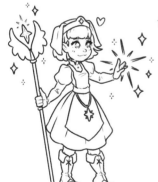

14. Neatly draw the line art over the sketch, then gently erase the sketch underneath. Add some highlights and hearts to the eyes, a gem in the headdress, dashes for blush on the cheeks, and sparkles around the character if you'd like.

15. Lastly, add color! I chose a blue palette using the brightest shades for the hair and lighter hues for the star above the staff and the dress. I added little pops of gold to represent the healing magic on the staff's wings and the stars.

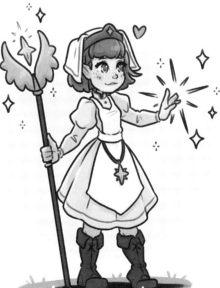

TAVERN KEEPER

This tavern has been in the keeper's family for generations, so while she may look sweet and friendly while serving you the best hot chocolate in the city, you'd better not make any trouble. Starting a brawl at the tavern is a one-way ticket to getting banned for life.

1. Sketch a round shape for the head and add a plus sign guideline for the face. Draw two ovals for the ears and a small U for the neck.

2. Draw a soft W-shaped upper body with a long, curved guideline down the middle.

3. For the lower body, sketch two thin rectangles. Then draw a triangle pointed down with two triangles on the sides for the hips.

4. Under the hips, sketch two long, thin Us for the thighs. Draw pointier Us for the lower legs. Then add the feet in two sections of a triangle and a rectangle.

5. Sketch circles for the shoulders, then add the arms with a U and teardrop shape. Angle the lower arms away from the body. Draw both hands as fists with a small circle above the right hand.

6. Sketch three large mugs, one in the left hand and two in the right hand. Try to make them slightly tilted.

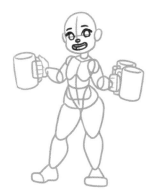

7. Add the eyes with a circle and a curved line around the top. Draw the eyebrows, nose, and a smiling mouth. Add lines for the teeth and tongue.

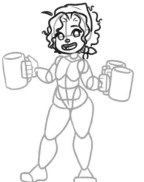

8. Sketch short, curly hair with two pieces framing the face. Add a scarf with a triangle on top and a knot at the bottom right of the head.

9. Draw an off-the-shoulder blouse with the sleeves rolled up over the elbows. Then add the corset starting just below the chest, with shoulder straps and Xs down the middle.

10. Sketch a ruched overskirt tied up on the right hip. Keep an eye on the way the skirt bunches up around the tie.

11. Add the under-skirt ending at the ankle. Then sketch a towel on the top left side of the skirt.

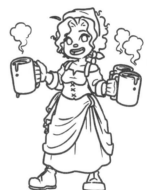

12. Draw the boots. Draw some liquid dripping down the mugs and steam clouds above. Sketch the hands where they aren't covered by the mugs.

13. Neatly draw the line art over the sketch, then gently erase the sketch underneath. Add some blush and highlights to the eyes and sparkles around the character if you'd like.

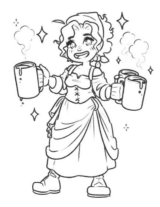

14. Finally, add color! I gave her red hair and a red towel with a green dress and headscarf. I made the overskirt lighter, with a checkered pattern. Then I kept the dress white and the shoes brown.

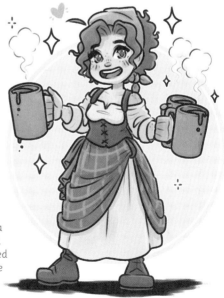

ALCHEMIST

In the city, you may come across a small apothecary with strangely colored smoke billowing out the crooked chimneys at all hours. This is a sign of an alchemist combining the arts of science and magic to create mystical concoctions that may or may not result in something impossible.

1. Sketch a round shape for the head and add a plus sign guideline for the face. Draw two ovals for the ears and a small U for the neck.

2. Draw a soft W-shaped upper body with a long, curved guideline down the middle.

3. For the lower body, sketch a rectangle. Then draw a triangle pointed down with two smaller upright triangles on either side for the hips.

4. Under the hips, sketch two long, thin Us for the thighs. Draw pointier Us for the lower legs. Then add the feet in two sections of a triangle and a rectangle. Make a slight arch in the bottom of the right foot.

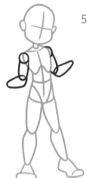

5. Sketch circles for the shoulders, then add the arms with a U and teardrop shape. Angle the arms away from the body.

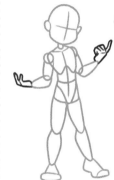

6. Sketch the left hand with its palm facing up and the right hand raised with the pointer finger pointing up.

7. In the left hand, add a round potions bottle. Draw an open book in the right hand. Sketch the rectangle cover and add a curved V above for the pages.

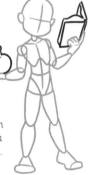

8. Add the eyes with a circle and a curved line around the top. Draw the eyebrows, nose, and a flat W shape for the mouth.

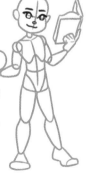

9. Sketch some short, spiky hair with curly bangs and two pieces framing the face. Make most of the hair flow to the right.

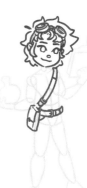

10. Add goggles wrapped around the top of the head. Add a belt around the hips and a strap crossing from the right shoulder to the left hip. Then draw a small bag.

11. Draw an apron and a sweater with a collar and baggy sleeves. Sketch the boots with a diamond shape over the knees. Then add pants tucked into them.

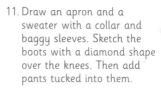
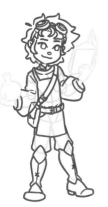

12. Add three vials tucked into the strap across the chest. Detail the book and add liquid in the bottle with a couple of puffs of smoke coming out of the top. Add a strap around each boot.

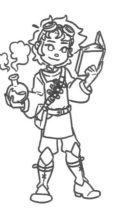

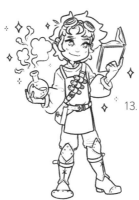

13. Neatly draw the line art over the sketch, then gently erase the sketch underneath. Add some dashes on the cheeks for blush, highlights in the eyes, and sparkles around the character if you'd like.

14. Let's add some color! I used dark blue for the sweater and purple for the liquid in the bottle. Then I used a lighter blue and purple on the apron, with browns for the belts and boots. For accents, I chose gold for the goggles and boots.

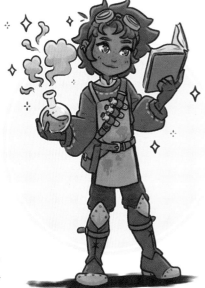

WIZARD

Wizards spend a lot of their time studying in the great library at the top of the city's castle. This wizard's favorite subject is the ancient arcane arts. So notable are they that adventurers often show up at their door when ominous, enchanted items end up in their hands.

1. Sketch a round shape for the head and add a plus sign guideline for the face. Draw two ovals for the ears and a small U for the neck.

2. Draw a soft W-shaped upper body with a long, curved guideline down the middle.

3. For the lower body, sketch a rectangle. Then draw a triangle pointed down with two small triangles on either side for the hips.

4. Under the hips, sketch the legs crossed at the thighs. Draw two long, thin Us for the thighs and pointier Us for the lower legs. Then add the feet in two sections of a triangle and a rectangle. Make a slight arch in the bottom of the foot on the right.

5. Sketch circles for the shoulders, then add the arms with a U and teardrop shape. Angle the arms away from the body.

6. Draw the right hand in a fist with the thumbs up and sketch a crooked line for the staff. Make the left hand raised with the fingers slightly fanned out.

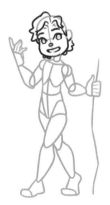

7. Add the eyes with a circle and a curved line around the top. Draw the eyebrows, nose, mouth, and beard. Sketch wavy hair, keeping the back clear for the hood.

8. Add a pointed hood on top of the head with a circle clasp just under the neck. Draw the billowing cloak starting at the clasp and wrapping it around the shoulders.

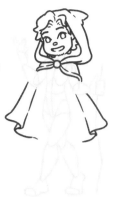

9. Draw the front of the coat underneath the cloak with a knotted belt at the waist. Make a split down the middle of the coat. Add the sleeves and hands.

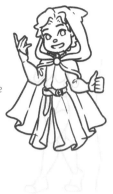

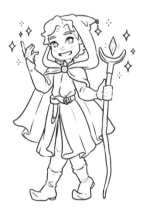

10. Sketch short boots with curved tips and add the pants where visible.

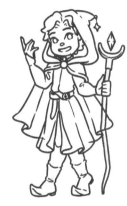

11. Draw the staff with a semi-circle at the top and a diamond floating above. At the tip of the hood, add a little star-shaped charm.

12. Neatly draw the line art over the sketch, then gently erase the sketch underneath. Add some dashes on the cheeks for blush, highlights in the eyes, and sparkles around the character if you'd like.

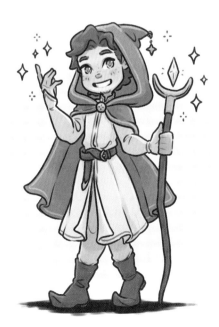

13. Now add color! I used varying shades of blue for the hair, cloak, coat, pants, and diamond of the staff. I added gold accents to the star charm, clasp, and staff.

THIEF

Beware while perusing the city's market. One second you have a purse full of coins at your side, then in a flash, it's gone. Rumor has it there's a magical thief wandering the alleyways, but the guards are yet to find a suspect!

1. Sketch a round shape for the head and add a plus sign guideline for the face. Draw two teardrop-shaped ears and a small U for the neck.

2. Draw a soft W-shaped upper body with a long, curved guideline down the middle.

3. For the lower body, sketch a rectangle. Then draw a triangle pointed down with two smaller upright triangles on either side for the hips.

4. Under the hips, sketch two long, thin Us for the thighs. Draw pointier Us for the lower legs. Then add the feet in two sections of a triangle and a rectangle. Make a slight arch in the bottom of the left foot.

5. Sketch circles for the shoulders, then add the arms with a U and teardrop shape. Angle the arms so the left arm is pointed down toward the hip and the right arm is pointed upward.

6. Draw the left hand in a fist resting on the hip and the right hand with the pointer finger pointing up.

7. Add two large, curved horns on the head and a curving tail starting at the hip, ending with an arrowhead point.

8. Add the eyes with a circle and a curved line around the top. Draw the eyebrows, nose, and a flat W shape for the mouth. Add a small dot under the mouth for a lip piercing.

9. Draw the hair with bangs in between the horns and two curly pieces in front of the ears. Then make a long, curving braid behind the back, with a bow tied at the end.

10. Draw a hooded cloak with a forked bottom edge and tassels at the tips. Sketch a corset and a blouse under the corset with wide sleeves and cuffs at the wrists. Add the right hand with an oval above it for a coin flipping in midair.

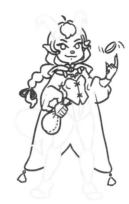

11. Add the left hand holding a small coin pouch. Detail the pouch with a dashed line for the stitching.

12. Add a belt around the hips. On the right hip, draw a small dagger. Sketch some slim pants and thigh-high boots with a folded top and a curved toe.

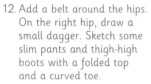
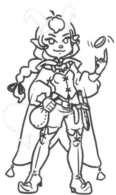

13. Add some rings around the horns and thicken the tail.

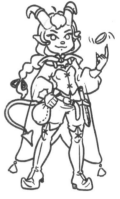

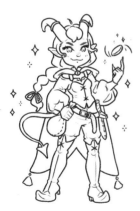

14. Neatly draw the line art over the sketch, then gently erase the sketch underneath. Add some dashes on the cheeks for blush, highlights in the eyes, and sparkles around the character if you'd like.

15. Add some color! I picked red for the skin and corset, and blue for the cape, blouse, hair bow, and pants. To make it a bit playful, I gave the corset a floral pattern and made the pants striped.

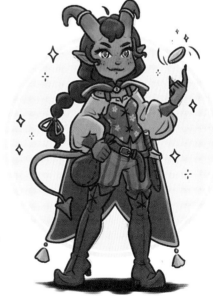

KNIGHT ✦

Knights dedicate their lives to guarding the city's royal family, even if it requires fighting a dragon or a horde of the undead—which they'll gladly do. It's the princess that ends up being more difficult to protect, with her habit of climbing out windows and ending up a step away from trouble.

1. Sketch a round shape for the head and add a plus sign guideline for the face. Draw two teardrop-shaped ears and a small U for the neck.

2. Draw a soft W-shaped upper body with a long, curved guideline down the middle.

3. For the lower body, sketch a rectangle. Then draw a triangle pointed down with two smaller upright triangles on either side for the hips.

4. Under the hips, sketch two long, thin Us for the thighs. Draw pointier Us for the lower legs. Then add the feet in two sections with a triangle and a rectangle.

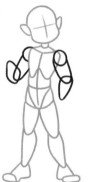

5. Sketch circles for the shoulders, then add the arms with a U and a teardrop shape. Angle the left arm so that it makes a V. Then make the right arm point down.

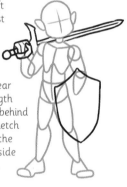

6. Draw the left hand as a fist holding a large sword. Make a large guard next to the ear with the length of the blade behind the head. Sketch a shield on the lower right side of the body.

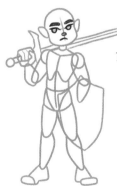

7. Add the eyes with a circle and a curved line around the top. Draw the eyebrows, nose, and a frowning mouth.

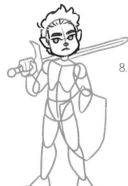

8. Outline the face and ears. Draw the hair with long spikes on top and short sides.

9. Draw the shoulder pauldrons and chest plate, with a collar of a doublet underneath. Detail the shield with a border and a faint plus sign to give it a bit of shape.

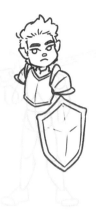

10. Sketch the bottom of the doublet with a diagonal grid pattern. Add a belt and a sheath with a long triangle at the hip. Draw the pants, greaves (lower leg armor), and shoes.

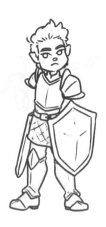

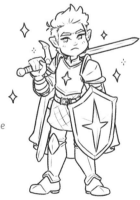

11. Add the sleeves under the shoulder pauldrons and draw straps with rings to connect the vambraces (wrist armor) on the forearms. Add the hand and detail the sword.

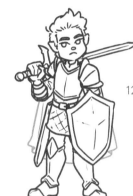

12. Draw a cape behind the body with a wavy bottom and creases along it.

13. Neatly draw the line art over the sketch, then gently erase the sketch underneath. Add some dashes on the cheeks for blush, a star on the chest and shield, highlights in the eyes, and sparkles around the character if you'd like.

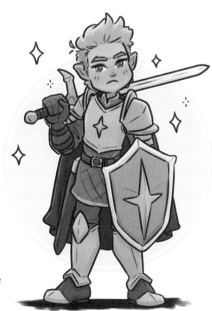

14. Lastly, let's color! I used purple for the clothing and shield, and silver for the armor and sword. I added small touches of gold for the sword's guard and the star details.

PRINCESS

The future queen of the land has great aspirations for the future of her people. However, she also dreams of having an adventure and setting out on her own quest into unknown, magical lands.

1. Sketch a round shape for the head and add a plus sign guideline for the face. Draw a small oval ear and a small U for the neck.

2. Draw a soft W-shaped upper body with a long, curved guideline down the middle.

3. From the bottom of the W, draw an upside-down triangle with two upright triangles on the sides for the hips.

4. Draw two large ovals for the thighs and circles for the knees.

5. Add two long, thin Us for the lower legs, with the right slightly tilted outward. Then add the feet in two sections of a triangle and a rectangle. Make a slight arch in the bottoms of the feet.

6. Sketch circles for the shoulders, then add the arms with a U and teardrop shape. Angle the left arm up, so that it makes a V, and the right arm out and away from the body.

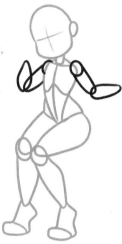

7. Sketch the left hand as a fist resting against the head. Draw the right hand relaxed with the palm facing down.

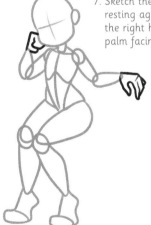

8. Add the eyes with a circle and a curved line around the top. Draw the eyebrows, nose, and a flat W shape for the mouth.

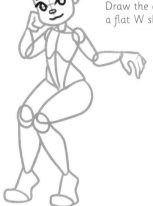

PRINCESS ✦ 💗

(continued)

9. Outline the face and ear. Add curly hair around the top and sides of the face. Sketch a tiara with an oval jewel in the middle and resting on the forehead.

10. Draw the rest of the long hair draping around the shoulders. To make it curly, draw a lot of little curves (a bit like little clouds). On the sides of the crown, add some small flowers.

11. Draw the neck and shoulders. Sketch the dress with an off-the-shoulder neckline, billowing sleeves that drape from the forearms, and a long skirt pooling around the feet and draping over the steps of the throne (see step 13). Add the hands.

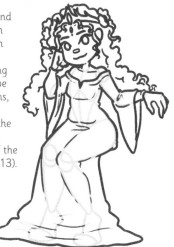

12. Around the figure, sketch the curved arms and seat of the throne. Place the chair's arms under the left elbow and the right hand and make the seat more visible on the right.

13. Draw the right leg of the throne, and a couple of shallow steps underneath.

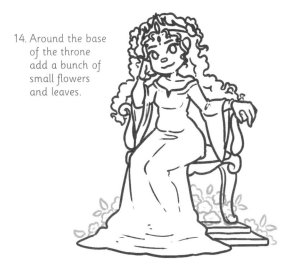

14. Around the base of the throne add a bunch of small flowers and leaves.

15. Neatly draw the line art over the sketch, then gently erase the sketch underneath. Add some dashes on the cheeks for blush, highlights in the eyes, a dainty necklace, and sparkles around the character if you'd like.

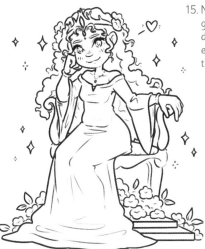

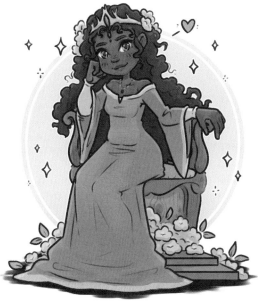

16. Time for color! I picked a peach shade for her dress, light pink for the tighter sleeves, and gold accents on the hem. I made the throne brown for a natural, wooden structure, and made the flowers pink.

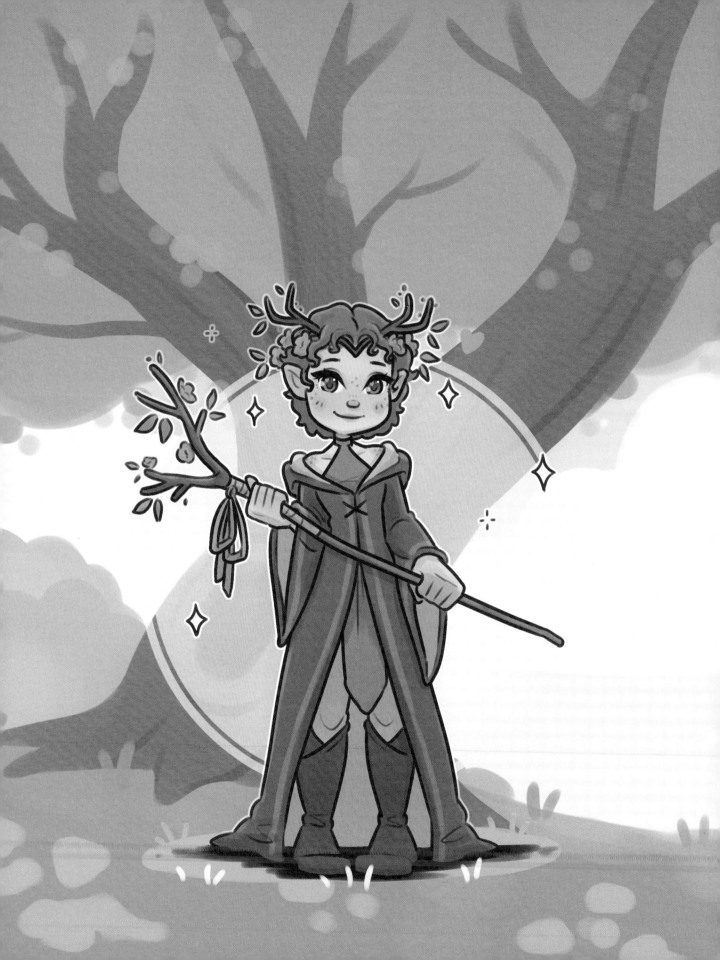

THE
ANCIENT
FOREST

LIGHT ELF

One of the most powerful beings of The Ancient Forest, the light elf spends her immortal lifespan acting as a guide and protector of the region. Whenever she grows lonely, she wanders out of the forest to converse with immortals of the other territories.

1. Draw a round shape for the head with a plus sign (+) guideline for the face. Draw two triangles on each side for the pointed ears and a small U for the neck.

2. Draw a soft W-shaped upper body with a long, curved guideline down the middle.

3. Add a partial rectangle to complete the torso. Draw an upside-down triangle for the lower body with two smaller upright triangles on either side to create the hips.

4. Sketch the legs with two long Us connected to two diamonds. Add two feet in two sections of a triangle and a rectangle.

5. Draw circles for the shoulders, then add the arms with a U and teardrop shape. Bend the lower arms away from the body.

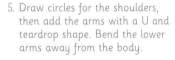

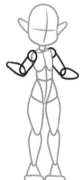

6. Sketch the left hand with the first finger pointed up to a sun. Draw the right hand in a fist with a straight line for the staff.

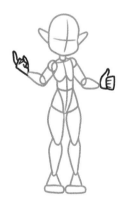

7. Sketch the dress with a square neckline, draping sleeves, and a long flowing skirt. Add a belt that loops around the waist twice.

8. Draw the outline of the face, ears, and neck. Sketch the hair with two strands in front of the ears and arms.

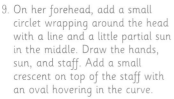
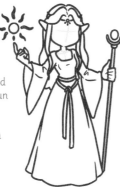

9. On her forehead, add a small circlet wrapping around the head with a line and a little partial sun in the middle. Draw the hands, sun, and staff. Add a small crescent on top of the staff with an oval hovering in the curve.

10. Add the eyes with a circle and a curved line around the top. Draw the eyebrows, nose, a flat W shape for the mouth, and dashes for blush.

11. Neatly draw the line art over the sketch, then gently erase the sketch underneath. Add highlights and hearts to the eyes and some sparkles around the character if you'd like.

12. When coloring, I chose a pale blue for the dress, eyes, and gem of the staff. I made the hair light blonde and added gold accents to pair with the gold of the light magic.

GNOME

You'll find this gnome in a small village on the outskirts of the forest, enjoying a leisurely walk with a nice cup of tea. Though he's only half the size of the average man, you won't find a better hiking companion or guide to the forest.

1. Sketch a round shape for the head and add a plus sign guideline for the face. Draw two teardrop-shaped ears and a small U for the neck.

2. Draw a soft W-shaped upper body with a long, curved guideline down the middle.

3. For the lower body, sketch a rectangle with a trapezoid under it. Divide the trapezoid into three smaller triangles with two diagonal lines for the hips.

4. Under the hips, sketch two long, thin Us for the thighs. Draw pointier Us for the lower legs. Then add the feet in two sections of a triangle and a rectangle. Make the left foot slightly lifted off the ground.

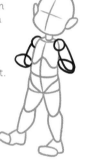

5. Sketch circles for the shoulders, then add the arms with a U and teardrop shape. Angle the arms so they're pointing to the left.

6. Next to the left arm draw a mug with a U shape. Add a curve at the top and a small rectangle on the bottom. Draw the left hand holding the mug. Make the right hand a fist.

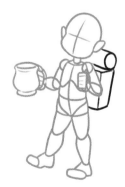

7. Sketch a block behind the right side of the body for the backpack. Add a cylinder on top for the bedroll.

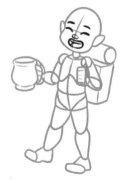

8. Draw two arcs for the closed eyes and two eyebrows above. Add a nose, a smiling mouth, and lines for the teeth and tongue.

9. Sketch short, curly hair with strands around the face. Draw a floppy hat. Outline the face and ears.

10. Add a waistcoat with a shirt collar and dots for buttons. Sketch the backpack straps over the shoulders with one end under the right hand. Add the pants and boots.

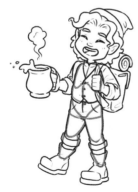

11. Draw the sleeves rolled up to the elbow. Sketch the arms, hands, and the mug. Add a splash of tea spilling over the rim of the mug.

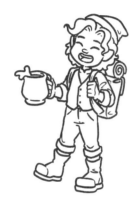

12. Detail the backpack with a flap at the top of the pack and a spiral on the side of the bedroll.

13. Neatly draw the line art over the sketch, then gently erase the sketch underneath. Add some dashes on the cheeks for blush and highlights in the eyes. Sketch a cloud of steam above the mug and some drops of liquid if you'd like.

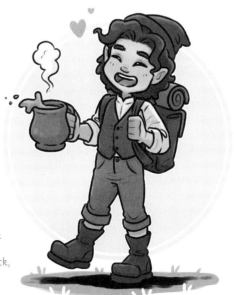

14. Finally, add color! I used earthy colors of brick red for the waistcoat and mug, and green for the bedroll and pants. I made the hat, backpack, and boots brown, and the tea orange.

FOREST ELF ✦

When entering The Ancient Forest, know that the forest elves are watching. They are experts in camouflage and archery, so you should always be on your best behavior, even if you can't see them.

1. Sketch a round shape for the head and add a plus sign guideline for the face. Draw two triangles for the pointed ears and a small U for the neck.

2. Draw a soft W-shaped upper body with a long, curved guideline down the middle.

3. For the lower body, sketch a rectangle. Then draw a triangle pointed down with two smaller upright triangles on either side for the hips.

4. Under the hips, sketch two long, thin Us for the thighs. Draw pointier Us for the lower legs. Then add the feet in two sections of a triangle and a rectangle.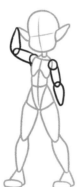

5. Sketch circles for the shoulders, then add the arms with a U and teardrop shape. Make the left arm lifted and bent at a ninety-degree angle and the right arm pointing down.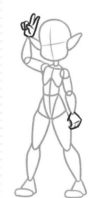

6. Sketch the left hand with two fingers pointed up and the right hand curved at the thigh.

7. Draw the shape of the bow held in the right hand with a rectangle at the center and two curving ends that get narrower at the tips.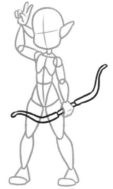

8. Add the eyes with a circle and a curved line around the top. Draw two slanted lines for the eyebrows, a nose, and a frowning mouth.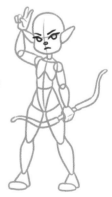

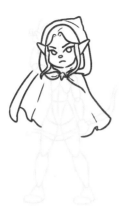

9. Add the ears and sketch a hood with a pointed tip. Draw the front of the hair with some waving strands in front of the ears. Draw a three-pointed clasp under the neck and add the cape flowing behind the body.

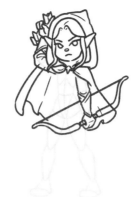

10. Draw the sleeves with criss-crossing braces (wrist armor) around the forearms. Next to the left hand, draw the forked fletchings (ends) of arrows with one in between her fingers. Add the bow and its string.

11. Outline the top with one piece hanging in the front. Then add another shirt underneath that has two slits at the hips. Sketch a knotted belt with one pointed end hanging down.

12. Add the legs with fitted pants and tall criss-crossing boots that come up just below the knee.

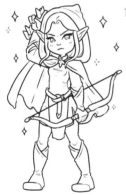

13. Neatly draw the line art over the sketch, then gently erase the sketch underneath. Add some dashes on the cheeks for blush, highlights in the eyes, and sparkles around the character if you'd like.

14. Let's color! I picked a green palette so the elf can blend in with the forest. I made the cape a darker green than the top with gold accents. The sweater and pants are shades of gray. Then I used brown for the armor, belt, and boots.

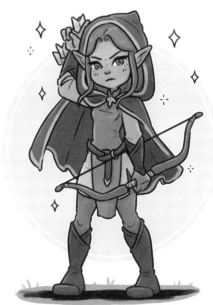

FAIRY

The forest is filled with mischievous fairies luring lost travelers to strange places. This fairy is no different and loves to drop them right in the middle of a fae or fairy event.

1. Sketch a round shape for the head and add a plus sign guideline for the face. Draw two triangles for the pointed ears.

2. Add two curving moth antennae on top of the head and a small U for the neck.

3. Draw a soft W-shaped upper body with a long, curved guideline down the middle.

4. Finish the upper body with a partial rectangle. Draw a circle under the left corner and extend the right side of the rectangle into a short curve.

5. Under the hips, sketch two long, thin Us for the thighs. Draw pointier Us for the lower legs. Make the right leg next to the left leg so that it is slightly hidden. Draw the feet in two sections.

6. Sketch circles for the shoulders, then add the arms with a U and teardrop shape. Angle the arms away from the body and add the shape of the splayed hands.

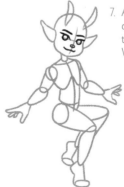

7. Add the eyes with a circle and a curved line around the top. Draw the eyebrows, nose, and a flat W shape for the mouth.

8. Sketch short, curly hair with two pieces hanging in front of the ears. Outline the face and ears and add some fluff to the antennae.

9. Draw a loose, wide-necked, cropped shirt with a collar and an X at the center. Add the wide sleeves with split cuffs that slightly cover the hands. Sketch the hands.

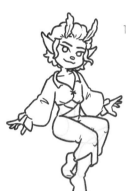

10. Draw a wide, wrapped belt around the waist, then draw pants tucked into boots. Keep an eye on where the pants crease at the knees and the top of the boots. Add little points to the shoes.

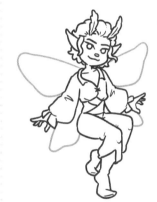

11. Add two rounded triangle wings behind the shoulders and another pair angled down.

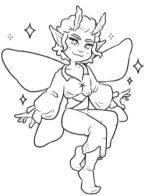

12. Neatly draw the line art over the sketch, then gently erase the sketch underneath. Add some dashes on the cheeks for blush, highlights in the eyes, and sparkles around the character if you'd like.

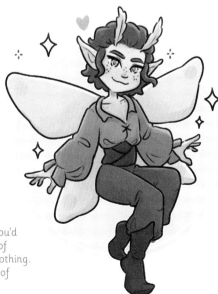

13. Finally, add color! You can pick any colors you'd like for these magical creatures! I used hues of green and teal for the antennae, hair, and clothing. The shadows are a light purple with accents of yellow for the eyes and dots on the wings.

DRUID

Druids are mages who specialize in nature-related magic. They live deep in the forest with the elementals, since their magical communities are inherently tied to each other.

1. Sketch a round shape for the head and add a plus sign guideline for the face. Draw two teardrop-shaped ears and a small U for the neck.

2. Draw a soft W-shaped upper body with a long, curved guideline down the middle.

3. For the lower body, sketch a rectangle. Then draw a triangle pointed down with two smaller upright triangles on either side for the hips.

4. Under the hips, sketch two long, thin Us for the thighs. Draw pointier Us for the lower legs. Then add the feet in two sections of a triangle and a rectangle. Make the tips of the feet touch at the middle.

5. Sketch circles for the shoulders, then add the arms with a U and teardrop shape. Angle the left arm up so that it makes a V and point the right arm downward.

6. Add the left hand in a fist facing up and the right hand in a fist facing down. Then add a long staff going through both hands. On the left end of the staff, draw a couple of branches.

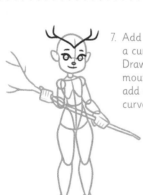

7. Add the eyes with a circle and a curved line around the top. Draw the eyebrows, nose, and mouth. Across the forehead, add a headdress with a V and curved forked ends.

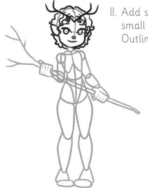

8. Add short, curly hair with small curls around the face. Outline the face and ears.

9. Draw the neckline of a halter top. Draw a hood wrapping around the shoulders and add the wide sleeves of the coat that hang down at the wrists.

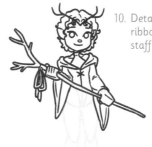

10. Detail the staff with a big ribbon wrapped around the staff just above the left hand.

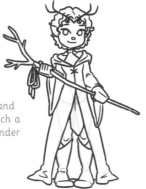

11. Draw the bottom of the coat pooling at the feet and opened at the front. Sketch a pointed panel of fabric under the coat. Then add some fitted pants tucked into criss-crossing boots.

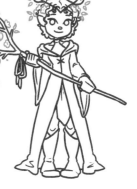

12. Add some flowers and leaves around the headdress and the branches of the staff.

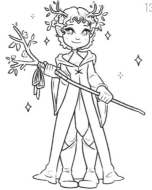

13. Neatly draw the line art over the sketch, then gently erase the sketch underneath. Add some dashes on the cheeks for blush, highlights in the eyes, and sparkles around the character if you'd like.

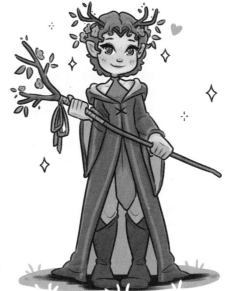

14. Finally, add color! As this is a druid, I stuck with a forest-y color palette of green and brown. I made the hair and ribbon orange with pink flowers.

FIRE ELEMENTAL

These hot-headed elementals may seem like the most intimidating of the four, but they're quite friendly once you get to know them. Just be mindful and stand a few steps outside their fire range in case they get angry and start spitting flames.

1. Sketch a round shape for the head and add a plus sign guideline for the face. Draw two triangles for the ears and add a small U for the neck.

2. Draw a soft W-shaped upper body with a long, curved guideline down the middle.

3. For the lower body, sketch a rectangle. Then draw a triangle pointed down with two smaller upright triangles on either side for the hips.

4. Under the hips, sketch two long, thin Us for the thighs. Draw pointier Us for the lower legs. Make the right leg bent and the left leg stretched out to the side. Then add the feet in two sections of a triangle and a rectangle.

5. Sketch circles for the shoulders, then add the arms with a U and teardrop shape. Angle the arms so they're pointed away from the body.

6. Sketch the left hand facing up, with the pointer finger and thumb lifted. Draw the right hand with the palm up and the fingers splayed open.

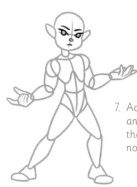

7. Add the eyes with a circle and a curved line around the top. Draw the eyebrows, nose, and a frowning mouth.

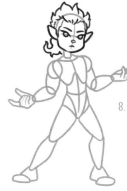

8. Outline the face and ears. Add spiked hair with shaved sides and a longer section on the bottom left. Make the hair spikes resemble flames.

9. Add a halter top with a collar and a diamond cutout in the middle of the chest. Add a knotted belt at the waist. Draw a section of fabric hanging down in between the legs with another section behind it.

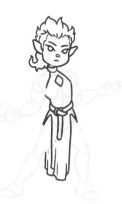

10. Sketch fitted pants tucked into knee-high boots. Add pointed toes to the boots.

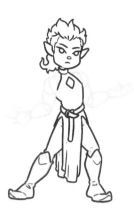

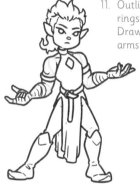

11. Outline the arms and add two rings around the upper arms. Draw wraps around the lower arms and hands with curved lines.

12. Draw flames above both hands and next to the right foot. Add small sparks around the hair.

13. Neatly draw the line art over the sketch, then gently erase the sketch underneath. Add some dashes on the cheeks for blush and highlights in the eyes if you like.

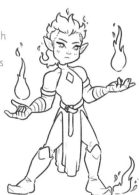

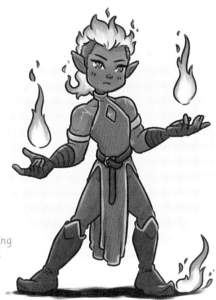

14. Add color! I gave them darker skin with splintering veins of bright orange. I also made the eyes and flaming hair the same orange. The dress is red with gold accents and black accessories.

WATER ELEMENTAL

Water elementals live in the river springs that flow through the forest all the way to The Enchanted City. You may spot a beautiful woman staring back at you from the water, but in a blink, they're gone with only a couple ripples left behind.

1. Sketch a round shape for the head and add a plus sign guideline for the face. Draw two curved ears with scalloped sides and a small U for the neck.

2. Draw a soft W-shaped upper body with a long, curved guideline down the middle.

3. For the lower body, sketch a rectangle. Then draw a triangle pointed down with two smaller upright triangles on either side for the hips.

4. Under the hips, sketch two long, thin Us for the thighs. Draw pointier Us for the lower legs. Then add the feet in two sections of a triangle and a rectangle. Make a slight arch in the bottom of the right foot.

5. Sketch circles for the shoulders, then add the arms with a U and teardrop shape. Angle the arms up and away from the body.

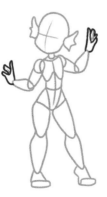

6. Sketch the hands raised with the palms facing away from the body.

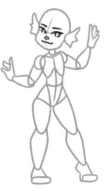

7. Add the eyes with a circle and a curved line around the top. Draw the eyebrows, nose, and a flat W shape for the mouth.

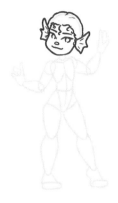

8. Sketch the face and ears. Add the top of the hair slicked back with a few curls stuck to the forehead.

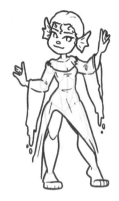

9. Add an off-the-shoulder dress with sleeves that hang down at the forearms. Make the fabric look like it's wet and dripping. Add a large split at the left hip. Draw the shoulders, arms, hands, legs, and feet.

10. Transition the bottom of the skirt into cloud-like shapes of bubbling water. Add a few little bubbles around the edges. Add the rest of the hair down the back with rounded, cloud-like ends similar to the skirt.

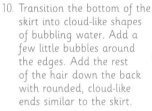
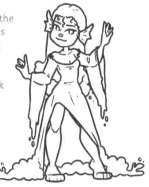

11. Sketch a twisted stream of water with some dripping edges.

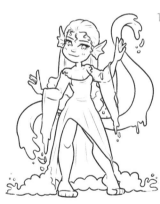
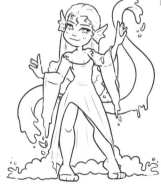

12. Neatly draw the line art over the sketch, then gently erase the sketch underneath. Add some dashes on the cheeks for blush and highlights in the eyes if you like.

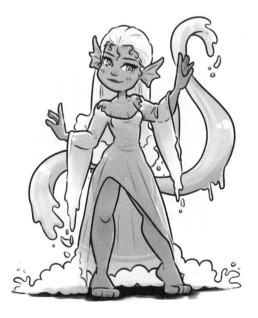

13. Finally, add color! I went fully blue on the clothing, skin, and water. The hair is light blue with pink ends, similar to the ends of the sleeves and skirt. For accents, I used purple for the shading and yellow for the eyes.

AIR ELEMENTAL

Air elementals are nearly impossible to spot. They drift through the forest on a mystical breeze and are never in one place for longer than a second. If you're lucky, you might hear their faint singing as the wind blows in your direction.

 1. Sketch a round shape for the tilted head and add a plus sign guideline for the face. Draw two long triangles for the pointed ears and a small U for the neck.

 2. Draw a soft W-shaped upper body with a long, curved guideline down the middle. Angle the body the opposite way to the head.

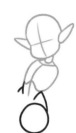 3. Under the upper body, add two upside-down Vs on the sides. Below the right V, add a circle for the thigh.

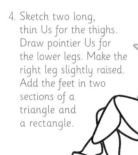 4. Sketch two long, thin Us for the thighs. Draw pointier Us for the lower legs. Make the right leg slightly raised. Add the feet in two sections of a triangle and a rectangle.

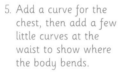 5. Add a curve for the chest, then add a few little curves at the waist to show where the body bends.

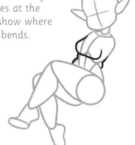 6. Sketch circles for the shoulders, then add the arms with a U and teardrop shape. Angle the left arm up and the right arm away from the body.

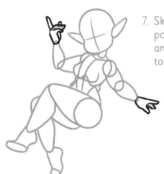 7. Sketch the left hand with the pointer finger pointing up and the right hand splayed to the side.

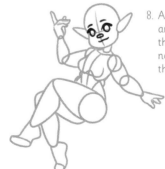 8. Add the eyes with a circle and a curved line around the top. Draw the eyebrows, nose, and a flat W shape for the mouth.

9. Outline the face and ears. Sketch the curly hair like clouds with some curls around the face.

10. Draw the arms and add the top of a strappy dress with a V neckline. Add some creases on the chest and stomach. Start the skirt draping over the right thigh.

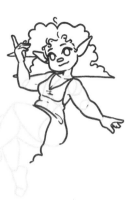

11. Sketch the legs and feet, adding some toes on the feet. Draw the start of a cloud underneath the thighs.

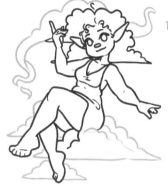

12. Underneath the thighs add some clouds, making her dress transform into it while she sits on top. Add a cloud behind her head with ends that stretch out and swirl like ribbon.

13. Neatly draw the line art over the sketch, then gently erase the sketch underneath. Add some dashes on the cheeks for blush and highlights in the eyes if you like.

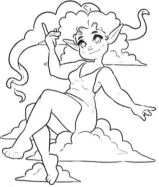

14. Last step is color! I made the clouds a pale pink and the skin purple with hot pink for shading, but you can get creative with any color you'd like!

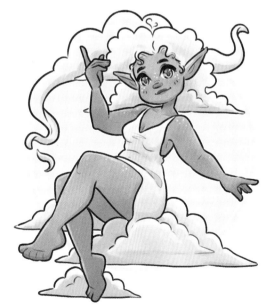

EARTH ELEMENTAL

It is believed that an earth elemental created The Ancient Forest from a single seed millennia ago. The forest emerged overnight and has been the home to all earth elementals ever since.

1. Sketch a round shape for the head and add a plus sign guideline for the face. Draw two teardrop-shaped ears and a small U for the neck.

2. Draw a soft W-shaped upper body with a long, curved guideline down the middle.

3. For the lower body, sketch a rectangle with a trapezoid under it. Divide the trapezoid into three smaller triangles with two diagonal lines for the hips.

4. Under the hips, sketch two long, thin Us for the thighs. Draw pointier Us for the lower legs. Then add the feet in two sections of a triangle and a rectangle. Make the left foot point away from the body.

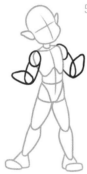

5. Sketch circles for the shoulders, then add the arms with a U and teardrop shape. Angle the lower arms so that they create a V.

6. Add the left hand with the palm facing up and the right hand pointing away.

7. On top of the head, draw two curving, pointed horns. Add a few butterflies around the body with one resting on top of the right hand's pointed finger.

8. Add the eyes with a circle and a curved line around the top. Draw the eyebrows, nose, and a flat W shape for the mouth.

9. Sketch long, flowing hair with small braids on the sides of the face in front of the ears. Detail the horns with some branches, forked ends, and leaves. Outline the face and ears.

10. Draw the sleeveless shirt with a collar and add a seam and buttons on the left side. Add a braided belt with a knot in the middle and make a slit on the left thigh.

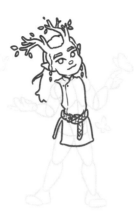

11. Sketch the pants tucked into criss-crossing boots. Draw the boots so they do not cover the toes, kind of like fingerless gloves.

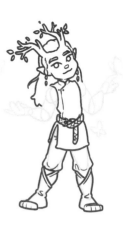

12. Add the arms and hands with some fingerless gloves that end at the upper arm.

13. Add some more detail to the butterflies with heads, bodies, and antennae. Draw some simple leaves swirling behind the body.

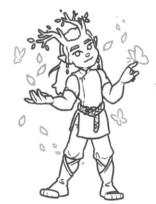

14. Neatly draw the line art over the sketch, then gently erase the sketch underneath. Add some dashes on the cheeks for blush and highlights in the eyes if you like.

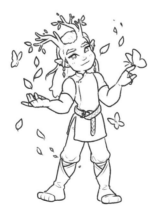

15. Let's color! I picked green for the hair, eyes, and clothing. I made the horns blend seamlessly into the head. Then I added small accents of yellow and gold for the butterflies and trim of the tunic.

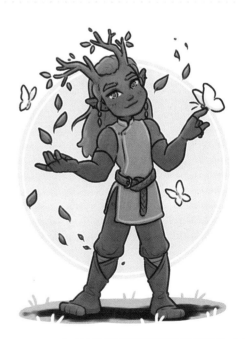

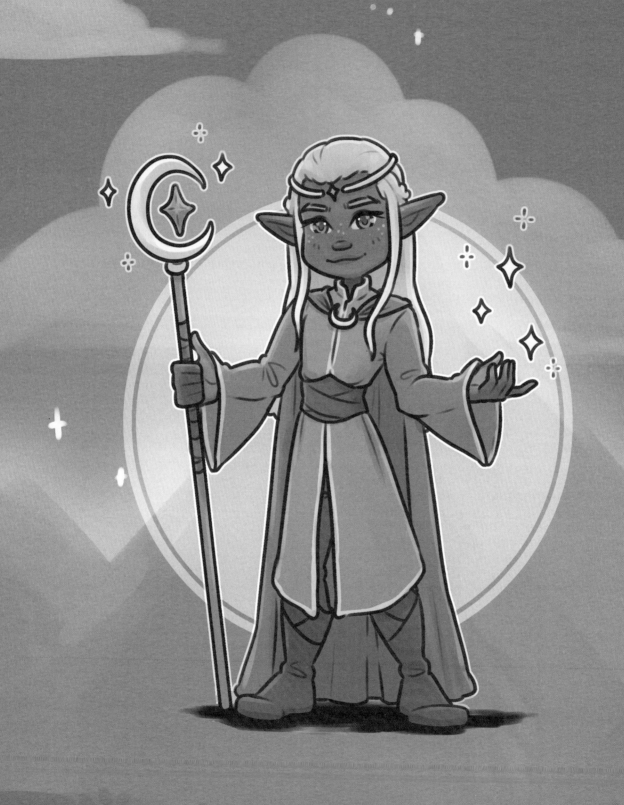

THE MOONLIT MOUNTAINS

GOBLIN

Goblins guard their village at the base of the mountains to ensure no harm comes to their home. But keep an eye on your valuables when visiting, for when they are not on duty, they enjoy collecting small and shiny objects to decorate their homes.

1. Sketch a round shape for the head and add a plus sign (+) guideline for the face. Add a small U for the neck.

2. Draw two pointed ovals on the sides of the head for the ears. Add a curved line down the middle of the ears.

3. Draw an egg shape for the body. Add a W guideline for the upper body and a line down the middle.

4. Under the body, sketch two long, thin Us for the thighs. Draw pointier Us for the lower legs. Add the feet in two sections of a triangle and a rectangle.

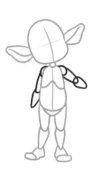

5. Sketch circles for the shoulders, then add the arms with a U and teardrop shape. Angle the left arm pointing down and the right arm pointing to the side.

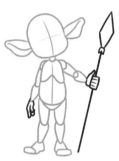

6. Draw the left hand hanging down and the right hand in a fist holding a spear.

7. Add small curves for the closed eyes. Sketch two circles above for the eyebrows. Add the nose and smiling mouth with triangle teeth.

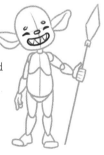

8. Outline the face and ears, adding a tuft of hair inside and at the tip of the ears. Add another tuft of hair like a dollop on top of the head.

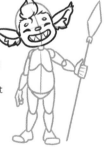

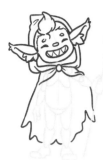

9. Draw a hood around the head with a triangle tip. Add an oval clasp under the neck. Sketch a cloak with a ragged bottom edge around the body.

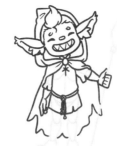

10. Add a long shirt with quarter-length sleeves and outline the arms and hands. Draw a piece of rope wrapped around the waist. Make the ends hang from the knot in front.

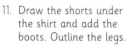
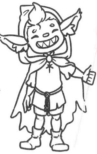

11. Draw the shorts under the shirt and add the boots. Outline the legs.

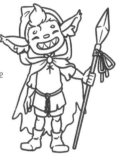

12. Sketch the spear, adding a ribbon around the staff where it meets the spearhead.

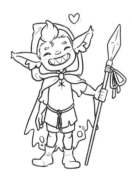

13. Neatly draw the line art over the sketch, then gently erase the sketch underneath. Add some dashes on the cheeks for blush, highlights in the eyes, and a heart around the character if you'd like.

14. For the color, I used a pale green for the skin and dark green for the hair. I chose dark teal for the cloak with a cream shirt and brown accessories.

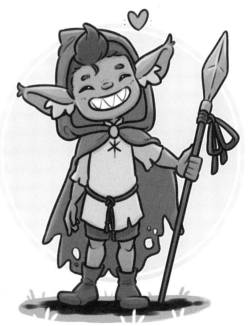

TROLL

Trolls are nocturnal creatures, roaming the mountains under the moonlight. But once the sun rises, if they're not indoors, they risk turning to stone before the moon shines again.

1. Sketch a round shape for the head and add a plus sign guideline for the face. Add a small U for the neck.

2. Add two large, pointed ears with a line down the middle.

3. Draw a soft W-shaped upper body and a big, curved U for the belly. Add a curved guideline line down the middle.

4. Under the hips, sketch two long, thin Us for the thighs. Draw pointier Us for the lower legs. Then add the feet in two sections of a triangle and a rectangle. Angle the left foot to the side so that we see the profile.

5. Sketch circles for the shoulders, then add the arms with a U and teardrop shape. Make both arms hang down.

6. Add both hands hanging down from the arms. Make sure you can see the profile of the left hand and the top of the right hand.

7. Draw a wiggly line for the tail at the right hip. Make a curving teardrop shape for the tufted tip.

8. Add the eyes with a solid circle and a curved line around the top. Above the eyes add two little tufts for the eyebrows. Add a nose and W-shaped mouth with two triangle teeth.

9. Draw some fluff around the bottom of the face. Add fluffy shoulder-length hair and two braids framing the face with a ring at the end of each braid. Outline the ears and add little tufts at the tips.

10. Add a shirt with a V split and slightly torn sleeves. Sketch the overalls with shorts. Make a kangaroo pocket on the stomach and add dashed lines for the stitching. Outline the arms and hands.

11. Outline the legs and feet, adding little tufts of fur at the back of the calves. Sketch the tail so it tapers toward the tufted tip.

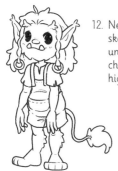

12. Neatly draw the line art over the sketch, then gently erase the sketch underneath. Add some dashes on the cheeks for blush and red and white highlights in the eyes.

13. Add some color! I picked beige for the hair and skin tone, making the hair just slightly darker than the skin for a neutral look. I chose dark green for the overalls and gold for the rings in the braids.

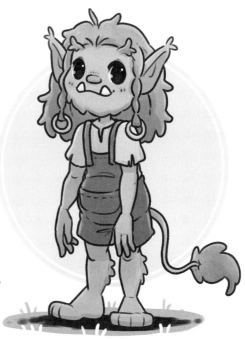

SKELETON

Skeletons walk these lands thanks to the magic of necromancy. While they don't remember who they were when they were alive, this skeleton is quite friendly to the residents of The Moonlit Mountains.

1. Sketch a round shape with a flat bottom for the top of the head. Add a plus sign guideline.

2. Add three scalloped curves underneath the flat bottom and a U shape under that for the jaw.

3. Add a line coming down from the left of the jaw for the spine. Then sketch the W-shaped ribcage slightly off-center of the spine. Add a rounded apple shape for the hips below the ribs.

4. Draw two small circles on either side of the hips with two smaller circles below. Then draw the feet in two sections of a long and thin rectangle. Connect the circles and feet with lines.

5. Sketch circles for the shoulders and the elbows, then connect with a straight line. For the forearms, draw a straight line for the left and a diagonal line for the right to make a V.

6. Sketch the left hand hanging down and the right hand open in a wave. Leave a gap between the hand and the fingers to resemble bones.

7. Outline the head and jaw. Add two rounded triangles for the eye sockets and an upside-down heart for the nose.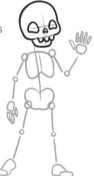

8. Detail the ribs with three horseshoe-shaped bones curved around an oval center. Then draw an oval on top of each side.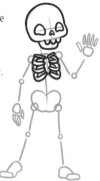

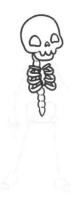

9. Detail the spine with three connected circles and a triangle.

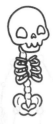

10. For the hips, outline the heart shape and make another heart around the triangle at the bottom of the spine.

11. Thicken the leg bones, making sure the lower leg is split into two bones. Blend the top circle with the bones but keep the knee circle separated. Outline the feet and add the toes.

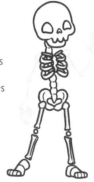

12. Thicken the arm bones. Keep the arms in two sections with a separation at the elbow. Add the hands and detail the three sections of each finger bone.

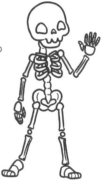

13. Neatly draw the line art over the sketch, then gently erase the sketch underneath. Add a little crack in the skull, some dashes on the cheeks, and a heart and some sparkles if you'd like.

14. Lastly, add color! I kept my skeleton pretty simple. If you'd like, make the bones an off-white color and add some shading. I used pink when shading mine. You can also add some blush to the cheeks for a cuter look.

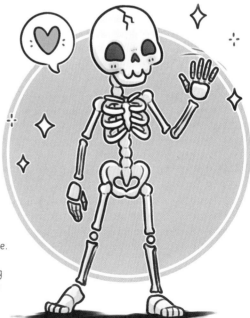

ORC

Though orcs have a fearsome reputation, they can be splendid adventuring companions. As one of the best fighters on the mountain, this orc loves a good brawl. Afterward, you can find them buying everyone a round of drinks at the nearby tavern.

 1. Draw a round shape for the head with a plus sign guideline. Draw two pointed ears and a small U for the neck.

 2. Draw a soft W-shaped upper body with a long, curved guideline down the middle.

 3. Complete the torso with a partial rectangle. Sketch an upside-down triangle for the lower body with two flared triangles on either side for the hips.

4. Draw two long Us for the thighs and two smaller Us for the lower legs. Add two feet in two sections of a triangle and rectangle.

5. Draw circles for the shoulders, then add the arms with a U shape and a rounded triangle for the lower arms. Angle both lower arms to the left.

6. Sketch the right hand so the fingers rest on the hip. Make the left hand curved facing down, and draw an oval with a line to the ground underneath.

7. Draw a furry cloak behind the body with a piece draped over the right shoulder. Use soft lowercase W and M shapes to create the fluffy texture.

8. Sketch the outline of the face, neck, and ears. Add the hair with a shaved right side, swooping locks moving left on the top, and longer strands down the back.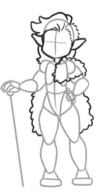

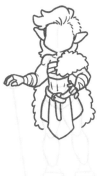

9. Add bandage wraps in crossing sections on the chest and forearms. Draw a knotted belt and the skirt with a long, pointed middle panel. Outline the arms and hands and add fingerless gloves.

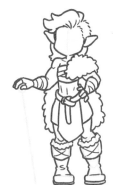

10. Draw the boots with a fur trim just below the knees and a wider section just below that. Add a small wrinkle where the boots crease at the ankles and thicken the soles.

11. Draw an axe under the left hand. Detail the handle, the hexagon center, and winged blades. Make the tip a sharp triangle.

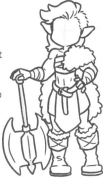

12. Draw an eye with a circle with a curved line around the top. Make the other eye winking with a curved line. Add the eyebrows, nose, a curved mouth with two triangle teeth, and dashes for blush.

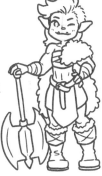

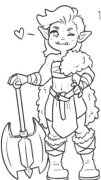

13. Neatly draw the line art over the sketch, then gently erase the sketch underneath. Add highlights and hearts to the eyes. If you'd like, draw a little heart near the head to express the wink!

14. Finally, add some color! I made a classic fantasy orc, with green skin and pale pink hair. I used red, gray, and brown for the accessories, and gold on the axe. But feel free to color your orc however you want!

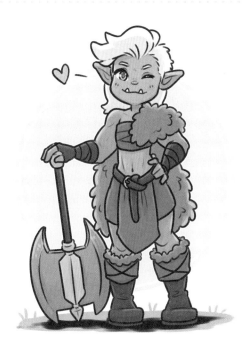

DARK ELF

With the power to discern the future through the constellations, this nocturnal immortal spends his time studying the moon and stars. Many creatures who travel across the land request his predictions and advice.

1. Sketch a round shape for the head and add a plus sign guideline for the face. Draw two pointy ears and a small U for the neck.

2. Draw a soft W-shaped upper body with a long, curved guideline down the middle.

3. For the lower body, sketch a rectangle. Then draw a triangle pointed down with two smaller upright triangles on either side for the hips.

4. Under the hips, sketch two long, thin Us for the thighs. Draw pointier Us for the lower legs. Then add the feet in two sections of a triangle and a rectangle. Angle the feet slightly away from each other.

5. Sketch circles for the shoulders, then add the arms with a U and teardrop shape. Angle the arms so they're pointing away from the body.

6. Make the left hand a thumbs up holding a staff with a crescent moon at the top. Draw the right palm facing up with the fingers slightly bent.

7. Add the eyes with a circle and a curved line around the top. Draw the eyebrows, nose, and a flat W shape for the mouth.

8. Outline the face and ears. Add long hair in front of the ears and down the back. Around the forehead, add a circlet with a small diamond in the middle.

9. Draw a crescent moon-shaped clasp under the neck. Add a cape from the clasp and drape it down to the feet.

10. Sketch the top of the coat with a collar and wide sleeves. Add a wrapped belt around the waist and the end of the coat with a split at the bottom.

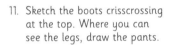

11. Sketch the boots crisscrossing at the top. Where you can see the legs, draw the pants.

12. Detail the staff with a little four-pointed star in the middle of the crescent.

13. Neatly draw the line art over the sketch, then gently erase the sketch underneath. Add some dashes on the cheeks for blush, highlights in the eyes, and sparkles around the character if you'd like.

14. Time for color! I used a purple theme, using a lighter shade for the hair and darker shades for the coat and cloak. I chose to do black and silver accessories to match the nighttime theme.

NECROMANCER

Since they live a quiet life in the mountains for centuries, no one quite knows the secret to a necromancer's extended life. Dark magic might be at play from the mysterious green glow that emanates from her dwelling.

 1. Sketch an oval for the head and add a plus sign guideline toward the left for the face. Draw a small oval ear.

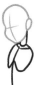 2. Draw a U for the neck that connects to the ear. Make a soft W-shaped upper body with a long, curved guideline down the middle.

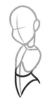 3. For the lower body, sketch a curve, then draw a trapezoid with a curved top and bottom.

4. Draw a circle hip and add a long U shape for the thigh. Add another narrow U for the lower leg. Draw the left leg crossing behind the right leg. Then sketch the feet in two sections of a triangle and rectangle.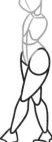

5. Sketch circles for the shoulders, then add the arms with a U and teardrop shape. Angle the arms so they're pointed up. Keep an eye on where the left arm is hidden behind the body.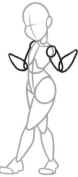

6. Sketch the left hand with the palm facing down and the first finger and thumb spread apart. Draw the right hand with the palm facing up and some of the fingers curled.

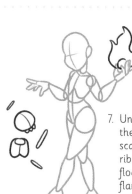 7. Under the left hand, sketch the rough shape of a skull with scalloped teeth, a W-shaped ribcage, and some oval bones floating in the air. Draw a small flaming circle in the right hand.

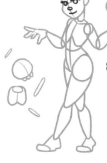 8. Add the eyes with a circle and a curved line around the top. Draw the eyebrows, nose, and a smiling mouth.

9. Outline the face and ear, and start the hair at the forehead. Then draw two curving lines for the hair around the head.

10. Draw the shoulders and the off-the-shoulder dress. Add a plunging neckline, sleeves with wide ends that drape down, and a slit at the right thigh. Draw a rope belt. Outline the arms, hands, legs, and feet.

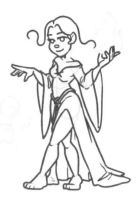

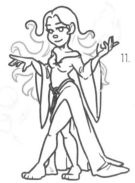

11. Complete the long, floating hair behind her arms. You don't have to be too precise, just keep the lines loose and curving.

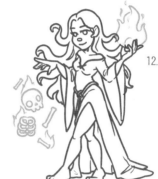

12. Detail the skull with eye sockets and a nose, the ribs with curved bones, and give the bones some shape. Add a few small flames around the floating bones and sketch the flame in her right hand.

13. Neatly draw the line art over the sketch, then gently erase the sketch underneath. Add some dashes on the cheeks for blush, highlights in the eyes, and sparkles around the character if you'd like.

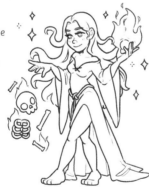

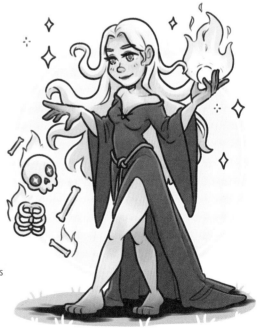

14. For the color, I gave her white hair and a black dress. I added small smudges of black on the tips of the hands and feet. For the fire and her eyes, I used a bright green for a pop of color.

WITCH ✦ ✦

There are many kinds of witches that walk this world—whether they're as protective as a guardian or as deceptive as the devil on your shoulder. This young city witch has traveled to the mountains in hopes of studying the occult arts. The residents here welcome her with open arms.

1. Sketch a round shape for the head and add a plus sign guideline for the face. Draw two small oval ears and a small U for the neck.

2. Draw a soft W-shaped upper body with a long, curved guideline down the middle.

 3. For the lower body, sketch a rectangle. Then draw a triangle pointed down with two triangles on either side for the hips.

 4. Under the hips, sketch two long, thin Us for the thighs. Draw pointier Us for the lower legs. Then add the feet in two sections of a triangle and a rectangle. Angle the toes inward and add a small arch to the bottom of the feet.

5. Sketch circles for the shoulders, then add the arms with a U and a teardrop shape. Angle the left arm up and away from the body and the right arm down and away.

6. On top of the right forearm, sketch an open book. Make the bottom and sides with straight lines and the top with curved lines.

7. Sketch the left hand with the first finger pointing up. Draw the right hand with the fingers wrapped around the top of the book.

8. Make the bottom of the skirt with a curved shape with wavy edges in front of the legs.

WITCH

(continued)

9. Add the eyes with a circle and a curved line around the top. Draw the eyebrows, nose, and an opened mouth with lines for the teeth and tongue.

10. Outline the face and ears. Sketch a bob of curly hair. Draw an oval around the top of the head for the brim of the witch's hat. Add a triangle point on top with a small crescent moon charm.

11. Sketch the top of the off-the-shoulder dress with puffy sleeves on the upper arms. Outline the shoulders, arms, and left hand.

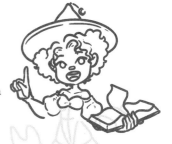

12. Draw the book and add some detail with a lifted page in the middle of the book. Add the right hand.

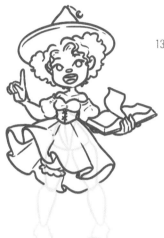

13. Add a corset around the waist with Xs along the front. Sketch the skirt using the wave you've already drawn to make the folds. Add a puffy pantaloon on the left thigh, or where you can see it on your figure.

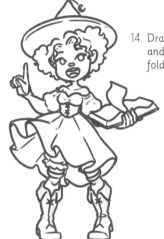

14. Draw over-the-knee socks and knee-high boots with a fold at the top and a heel.

15. Neatly draw the line art over the sketch, then gently erase the sketch underneath. Add some dashes on the cheeks for blush and highlights in the eyes.

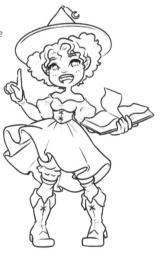

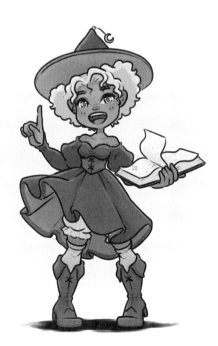

16. Finally, add some color! I chose a dark blue for the dress and hat, and a pastel pink for the hair and socks. The accessories of the corset, boots, and cover of the book are brown.

VAMPIRE

This warrior disappeared only to return centuries later slightly paler and with a penchant for blood. Guests are always welcome at his castle, but few ever return home. If you're visiting The Moonlit Mountains, be wary of dinner invitations from friendly strangers.

1. Sketch a round shape for the head and add a plus sign guideline for the face. Draw two small teardrop-shaped ears and a small U for the neck.

2. Draw a soft W-shaped upper body with a long, curved guideline down the middle.

3. For the lower body, sketch a rectangle with a trapezoid under it. Divide the trapezoid into three triangles with two diagonal lines for the hips.

4. Under the hips, sketch two long, thin Us for the thighs. Draw pointier Us for the lower legs. Then add the feet in two sections of a triangle and a rectangle. Angle the feet away from each other.

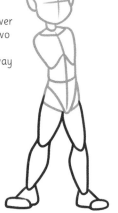

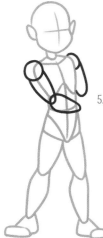

5. Sketch circles for the shoulders, then add the arms with a U and teardrop shape. Angle the lower left arm in front of the body, but don't add the lower right arm for now.

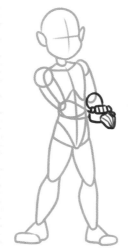

6. Add the left hand with a rectangular palm and the fingers. Then add the fingers of the right hand on top. Draw a curve above for the right forearm.

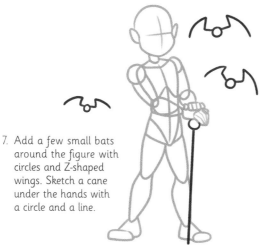

7. Add a few small bats around the figure with circles and Z-shaped wings. Sketch a cane under the hands with a circle and a line.

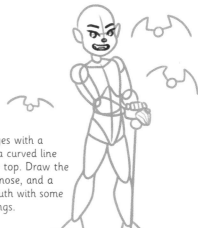

8. Add the eyes with a circle and a curved line around the top. Draw the eyebrows, nose, and a smiling mouth with some pointed fangs.

VAMPIRE

(continued)

9. Outline the face and ears. Draw the hair on top of the head with a short ponytail on the left side.

10. Draw a fur mantle on the shoulders with a chain linking the two sides together. Add a long cloak with some lines for the creases and folds and tears at the bottom.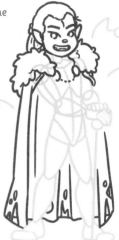

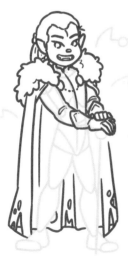 11. Sketch the top of the coat and the sleeves. Add long gloves that end in a point just below the elbow.

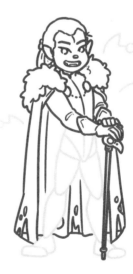 12. Detail the cane, making the handle the shape of a bird skull with a large eye and a curved beak.

13. Draw the lower half of the coat with a belt around the waist. Make a split in the middle. Add fitted pants and knee-high boots with a triangular top edge.

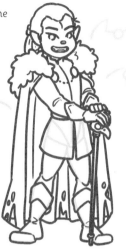

14. Go over the bats, adding the arching detail of the wings and little triangle ears.

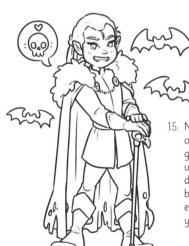

15. Neatly draw the line art over the sketch, then gently erase the sketch underneath. Add some dashes on the cheeks for blush, highlights in the eyes, and a little skull if you'd like!

16. Lastly, add color! I picked dark red for the coat and cloak, brown for the gloves and boots, and black for the hair, pants, and bats. I shaded around the eyes with red, but you can also add a little red drip to his mouth for an even spookier look!

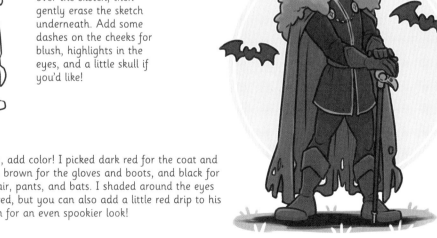

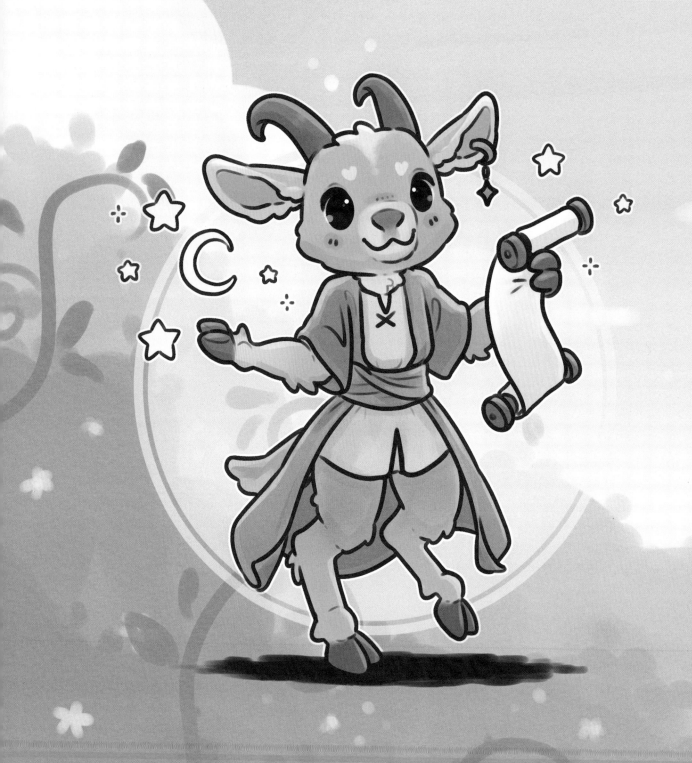

THE WILD
HAMLET

CHARMER

This little frog has big dreams of becoming a great adventurer one day and using his (very limited) magical abilities to save his village from evil.

1. Draw a large oval with two little bumps on top. Add a plus sign (+) guideline for the face.

2. Add a large, curved oval for the body with a guideline down the middle.

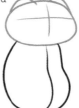

3. At the bottom of the body, add two ovals slightly angled outward. Then draw another narrow oval connected to the top of the first oval and angled down.

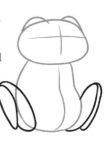

4. Draw the webbed feet with three long toes with a little circle at the tips.

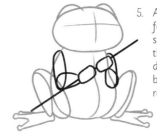

5. At the shoulders, draw an oval for the upper arm and teardrop shape for the forearm. Angle the forearms inward. Then draw a diagonal line that cuts between the arms with two rectangles along the middle.

6. Add two solid circles for the eyes and a wide flat W shape for the mouth.

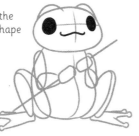

7. Draw a pointed hood around the head with a circle clasp under the chin. Leave some space just above the head. Add a little string tassel hanging from the tip of the hood.

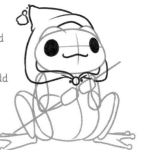

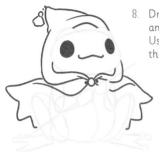

8. Draw the cloak from the clasp and floating around the body. Use a zig-zag pattern along the bottom edge.

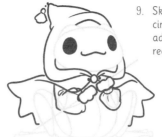

9. Sketch puffy sleeves that cinch at the wrists and add the hands using the rectangle guidelines.

10. Add the shirt with a collar, some Xs along the middle, and a split at the bottom. Outline the body, legs, and feet.

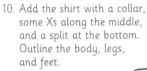
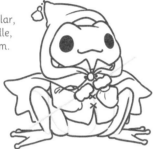

11. Detail the staff with a curved top and a floating oval gemstone above.

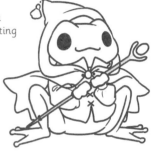

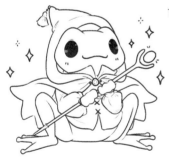

12. Neatly draw the line art over the sketch, then gently erase the sketch underneath. Add some dashes on the cheeks for blush, red and white highlights in the eyes, and sparkles around the character if you'd like.

13. The final step is to color! I picked a classic pale green for the body and a dark green for the cloak. I made the shirt orange and the gemstone purple. For the final touches, I used pink for the tassel, the clasp of the cloak, and the shirt.

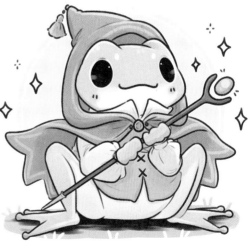

BANDIT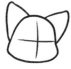

This kitty has traveled the world and picked up some nifty skills along the way. Most of them have to do with pickpocketing and dagger efficiency, but they're great skills for life in the hamlet nonetheless.

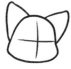

1. Draw a round triangle for the head with a plus sign guideline for the face. Add two large triangles for the ears.

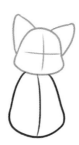

2. Sketch an egg shape for the body and add a guideline down the middle.

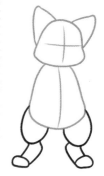

3. Add two large ovals under the body. Then draw the feet with a long rectangle and a rounded tip.

4. Sketch an oval for the upper arm and a teardrop shape for the lower arms. Angle the arms up so that they make a V.

5. Sketch rectangular fists for both hands. Then add daggers to each with a long pointed triangle, an oval guard, and a circle under the fist. Angle the left dagger up and the right dagger down.

6. On the left side of the body, draw a curving tail in the shape of the number 2.

7. Draw two solid eyes with a curve around each. Make the top slightly angled with small dashes above for a grumpy expression. Lightly draw a rounded trapezoid snout with a triangle nose and an upside-down V mouth.

8. Sketch a hood over the head with the ears peeking out. Draw a fish-shaped clasp under the chin. Then add a cape over the shoulders and behind the body with wavy ends.

9. At the neck and under the hood, add a thick scarf. Draw the end of the scarf hanging down on the left with a tasseled end. Outline the head and ears with fluffy edges. Add a hoop earring and whiskers around the hood.

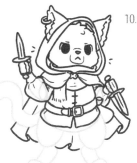

10. Draw the shirt and a belt with a pouch on the right side. Add puffy sleeves that cinch at the wrists and fingerless gloves. Add the daggers.

11. Draw the legs and tail, adding some fluff on the corners of the legs and the bottom of the belly. Outline the feet and detail the toes.

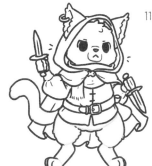

12. Neatly draw the line art over the sketch, then gently erase the sketch underneath. Keep only a faint outline of the snout. Add some dashes on the cheeks for blush and red and white highlights in the eyes.

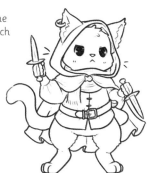

13. Let's add color! I made this character a gray tabby cat with stripes along the face, tail, and legs, but you can make it any breed you'd like! The cloak is green with a light blue scarf and a dark blue shirt. The accessories are brown and gold.

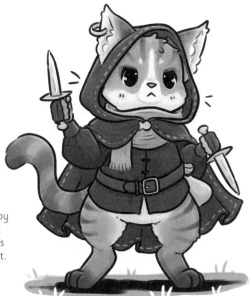

ENCHANTER ✦ ✦

A kit, or baby fox, was gifted a book of spells by a traveling mage. Ever since, they are known to frequently enchant all manner of objects, including the hat on their head.

1. Draw a rounded triangle for the head with a plus sign guideline for the face. Add two large triangle ears.

2. Add a small U for the neck, then draw an egg-shaped body. Sketch a curved guideline down and across the middle.

3. At the bottom of the body, draw a circle for the legs. Make the right leg inside the body and the left leg slightly hidden behind the body. Then attach two curved ovals for the feet.

4. At the shoulders, add an oval for the upper arms and a teardrop shape for the lower arms. Angle the left arm so that it is lifted from the body. Make the right arm rest on the leg.

5. Draw the right hand holding an open book. Draw the book with rectangles and wavy lines for the pages.

6. Draw the left hand holding a staff. For the staff, draw a straight line with a small circle on top. At the bottom of the body, draw a large fluffy tail that curls around the right leg.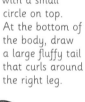

7. Add the solid round eyes with a curve around the top. In the middle of the face, draw a small C curve for the snout with a triangle nose and a little circle for an open mouth.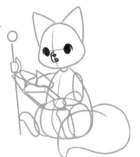

8. Draw a large oval wrapping around the top of the head with a curve for the inner edge. Between the ears, add a bent triangle for the tip.

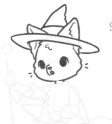

9. Outline the head and ears, adding some fluffy details for the fur. Add two dashes on either side of the head for whiskers.

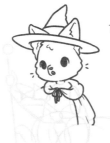

10. Draw a cape tied with a bow under the neck and wrapped around the shoulders. Sketch the hood piled on top and add the cape on the right side of the body.

11. Add the book with a little line hanging down from the spine for the bookmark. Draw puffy sleeves and outline the hands.

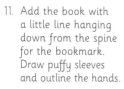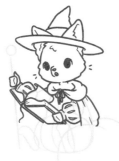

12. Add the lower body, legs, feet, and tail. Add little toe beans on the feet and fluff along the edges of the body and tail. Detail the staff with a branch-like setting holding the orb.

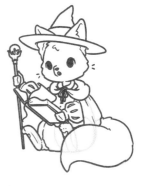

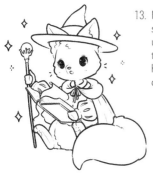

13. Neatly draw the line art over the sketch, then gently erase the sketch underneath. Add some dashes on the cheeks for blush, red and white highlights in the eyes, and sparkles around the character if you'd like.

14. Add some color! I used classic orange for the fox with cream patches and brown for the tips of the ears, hands, and feet. I chose purple for the hat and clothes and red for the staff's orb.

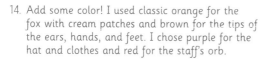

ARCHITECT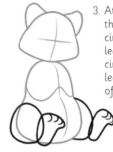

A gifted tinkerer, this raccoon has been building machines all over the town since they were young. Although some of their inventions have the tendency to combust, so keep a safe distance.

1. Draw a rounded triangle for the head with a plus sign guideline for the face. Add two small, rounded triangle ears.

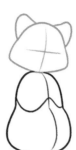

2. Draw an egg-shaped body. Add a soft W guideline across and a curved guideline down the middle.

3. At the bottom of the body, draw a circle for the left leg and a partial circle for the right leg. To the right of the legs, draw curved feet with toe lines.

4. Start the tail on the left with a C curve. Then draw a large oval in the shape of a J for the rest of the tail on the right.

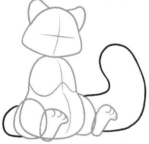

5. At the shoulders, draw an oval for the upper arms and a teardrop shape for the lower arms. Angle the arms inward.

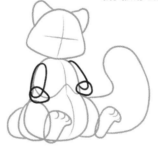

6. Draw the left hand with the fingers holding a circle. Add the right hand as a fist gripping a little hammer poised above the circle.

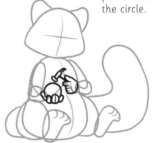

7. Sketch a pair of goggles strapped across the top of the head. Use ovals for the lens and curved lines for the straps.

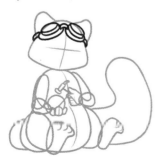

8. Add solid circle eyes with a curve around the top. Draw a round shape for the snout, a circle nose, and a curved mouth with two nails sticking out.

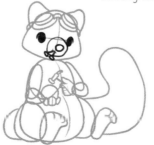

9. Sketch over the goggles and try to make them look 3D with more lines and shading. Outline the head and ears with fluffy edges. Around the sides of the face, add some whiskers.

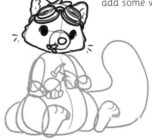

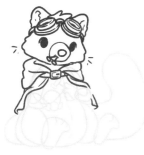

10. Draw bunched fabric around the shoulders for a hood. Draw the cloak falling down the sides. Make a leather strap for the clasp with a belt buckle in the middle.

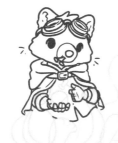

11. Draw the bottom edge of a simple shirt with rolled-up sleeves. Add the hands with fingerless gloves.

12. Detail the hammer and add some screws and a cog to the circle in the left hand.

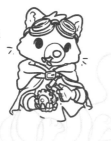

13. Add the legs and tail with fluffy details. Draw little hearts on the bottom of the feet. Then use hatching lines for scuff marks on the face and tail. Make some screws on the ground.

14. Neatly draw the line art over the sketch, then gently erase the sketch underneath. Add some dashes on the cheeks for blush, more scuff marks on the legs, red and white highlights in the eyes, and sparkles around the character if you'd like.

15. Add color! I stuck with the usual raccoon coloring of black and white with patches on the face. I chose a pink shirt and cloak, and brown goggles, belt, and gloves.

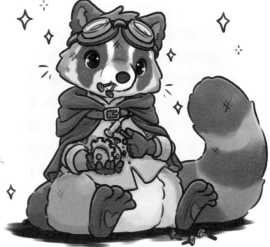

FORTUNE TELLER

Born with the ability to tell the future, this goat uses their talents for good. To keep the village safe, they advise residents to choose the right paths whenever danger lurks nearby.

1. Draw a round shape with pointed sides for the head with a plus sign guideline for the face.

2. Draw two pointed oval ears. On top of the head, draw two horns curving into points.

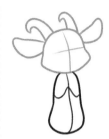

3. Add a long egg-shaped body. Sketch a soft W guideline across and a curved guideline down the middle.

4. At the bottom of the body, add an oval for the left thigh with a partial oval for the right. Attach the lower legs with angled lines and a circle at the end. Add the hooves with two triangle toes and one triangle heel.

5. Sketch circles for the shoulders, then add the arms with a U and teardrop shape. Angle the arms up and away from the body.

6. At the ends of the arms, add little hoof hands. Make the left "palm" up with diamond-shaped fingers and a circle at the base. Make the right hoof a "fist" with two fingers.

7. In the right hand, draw an open scroll. Sketch a cylinder for the top and bottom, then connect them with curved lines.

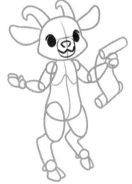

8. Add solid round eyes with a curve around the top. Draw a rounded square snout with a rounded triangle nose without the bottom tip. Then add a W shape for the mouth.

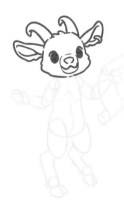

9. Outline the head, ears, and horns with some fluffy edges. On the right ear, add a hoop earring.

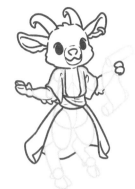

10. Draw the top with sleeves that reach the elbow. Sketch two panels of the open coat with a belt wrapped around the waist. Outline the arms and hooves, adding fluff to the elbows.

11. Sketch a simple shirt with a split neckline and bottom edge. Add the legs with fluffy edges. Add the hooves and draw a fluffy tail on the left.

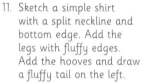
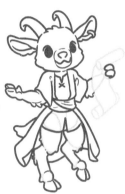

12. Detail the scroll, dividing the cylinders into three parts. Add a four-pointed star charm to the earring. Then add some stars and a crescent moon on the left and right.

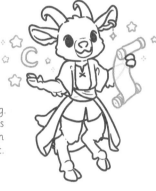

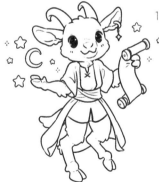

13. Neatly draw the line art over the sketch, then gently erase the sketch underneath. Add some dashes on the cheeks for blush and red and white highlights in the eyes.

14. For the color, I chose light teal for the clothes and light brown for the fur with pink shading. I made the horns and hooves brown, as well as the wooden pieces of the scroll. For some accents, I made the earring, belt, and trim of the cloak gold, and the stars and moon yellow.

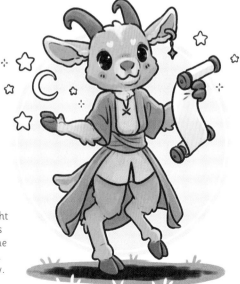

WARLOCK

On a journey to The Ancient Forest, this deer met with a druid seeking help with nature magic. Now, he is a master warlock and owner of a thriving magical garden.

1. Draw the head tilted to the right with a round shape with pointed sides and a plus sign guideline for the face. Add two teardrop-shaped ears with a line through the middle.

2. On the inner sides of the ears, draw the branching lines of the antlers. Start with one long curving line, then add smaller lines coming off it.

3. Add a small U neck, then draw a long egg-shaped body. Sketch a soft W guideline for the upper torso and a curved guideline down the middle.

4. At the bottom of the body, draw an oval for the left thigh with a partial oval for the right. Attach long rectangles for the lower legs. Just above the left thigh, add a short, curved tail.

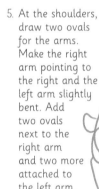

5. At the shoulders, draw two ovals for the arms. Make the right arm pointing to the right and the left arm slightly bent. Add two ovals next to the right arm and two more attached to the left arm.

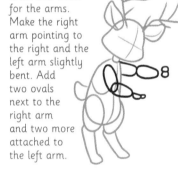

6. On top of the left hand, draw the rough shape of a snail with a spiral shell. Add a straight line going through the ovals of the right hand.

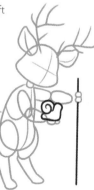

7. Make a small crescent moon on the forehead with a dotted line on the sides for the chain. Add two curved lines for closed eyes. Draw a backwards C for the snout, a partial triangle for the nose, and a flat W shape for the mouth.

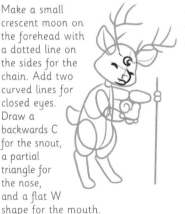

8. Thicken the antlers, making each branch taper into pointed tips.

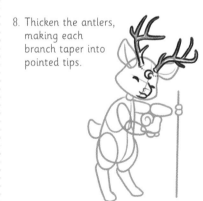

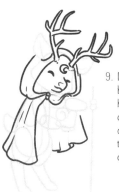

9. Draw a hood over the head, behind the antlers, and with holes for the ears. Make the clasp at the neck a small acorn. Drape the cape over the shoulders and let it hang down the sides of the body.

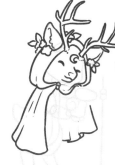

10. Add the ears and draw some flowers and leaves around them.

11. Outline the face with some fluffy edges. Add a shirt with long sleeves and a small collar. Add the hands. Detail the snail and staff, adding a hexagon gemstone floating above.

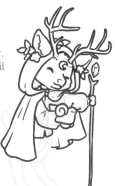

12. Outline the legs and tail with some fluffy edges. Add a line between the hooves to make them cloven.

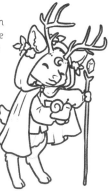

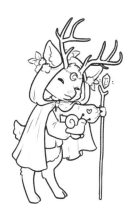

13. Neatly draw the line art over the sketch, then gently erase the sketch underneath. Add some dashes on the cheeks for blush and highlights in the eyes. You can also add a small heart above the snail if you'd like!

14. Add color! I picked green for the cloak and pink for the flowers and gemstone. I kept the fur a classic gold with cream patches and brown antlers and hooves. Then I made the shirt a simple white.

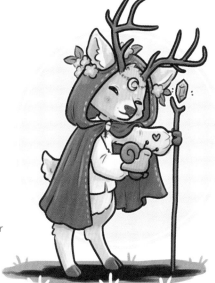

WARRIOR

Loyal friends are hard to come by. This protective bear chooses to live deep in the hamlet, but if you happen to cross paths and befriend him, you'll have a warrior in your corner for life—with the exception of the winter hibernating months.

1. Draw a round shape for the head with a plus sign guideline for the face. Add two semicircles for the ears.

2. Add an egg-shaped body with a guideline down the middle and a curved guideline across.

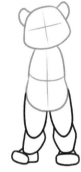

3. Under the body, sketch two long, thin Us for the thighs. Draw shorter Us for the lower legs. Then add the feet in two sections of two rectangles. Make the left foot angled to the left and the right foot facing forward.

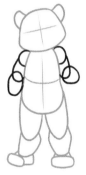

4. Sketch circles for the shoulders, then add the arms with a U and teardrop shape. Angle the left arm so it's hanging down with the right arm bent in an L shape.

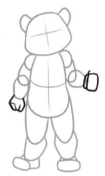

5. Add the hands as fists. Draw the lines of the fingers and thumb on the left hand but keep the right hand simple for now.

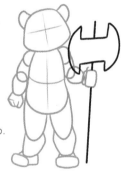

6. In the right hand, draw a straight line to the ground and add the winged shape of an axe head on top.

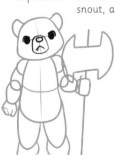

7. Add circle eyes with an angled line around the top for a grumpy expression. Draw a rounded rectangle snout, a rectangle nose, and an upside-down V mouth. Make a little tooth at the left corner of the mouth.

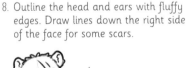

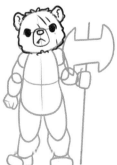

8. Outline the head and ears with fluffy edges. Draw lines down the right side of the face for some scars.

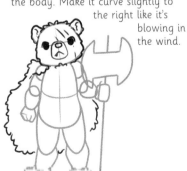

9. Draw a fluffy cloak starting at the left shoulder and let it hang behind the body. Make it curve slightly to the right like it's blowing in the wind.

10. Add a necklace with a small oval charm. Then add shoulder armor on the right shoulder with a strap across the chest. Make the strap tie in a knot in the middle with a buckle below.

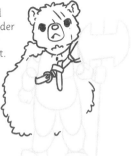

11. Draw a wrap around the waist with a piece of fur underneath. Then add the top of the baggy pants.

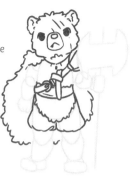

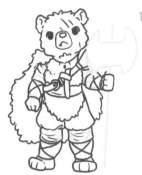

12. Add fluffy detail on the chest, arms, and hands. Draw wrapped fabric around the knees. Then add armor to the forearms and lower legs with an X on top. Add the feet and draw more scar lines on the left shoulder.

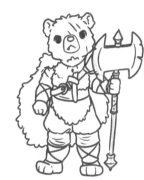

13. Detail the axe with spikes at the top and bottom of the pole, a grip for the handle, and some nicks in the blade.

14. Neatly draw the line art over the sketch, then gently erase the sketch underneath. Add some dashes on the cheeks for blush, highlights in the eyes, and sparkles around the character if you'd like.

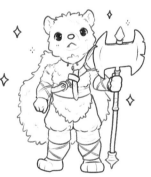

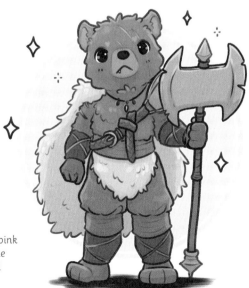

15. Finally, add color! I picked brown for the fur and pink for the scars and shading. I kept the pants a simple gray with a white cloak. For a pop of color, I used red for the armor and teal for the ties and wraps.

ARCHER

With keen eyesight and the ability to fly, this owl is a great archer. No one has been able to best them in a marksmanship competition so far. If you're ever in The Wild Hamlet and find yourself in need of an instructor, ask for the owl archer.

1. Draw a round shape with pointed sides for the head with a plus sign guideline for the face.

2. Add two pointed, teardrop-shaped ear tufts on top of the head.

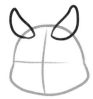

3. Draw a large egg-shaped body with a curved guideline down the middle and a W-shaped guideline for the torso.

4. Under the body, draw a U for the upper legs and a smaller U for the lower legs. Sketch bird feet with one rectangle for the left and two rectangles for the right.

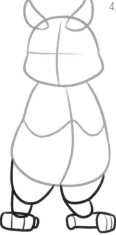

5. Draw a curved line starting at the right shoulder. Add an oval forearm angled to the left with a rectangle for the hand.

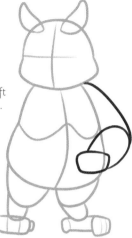

6. Draw a large sideways U shape for the upper left arm and make the forearm bent upward with a feathered hand. Keep two "fingers" curved and three splayed.

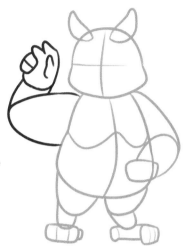

7. Draw a rectangular tail feather behind the left leg. In the right hand, sketch the shape of the bow with a rectangle middle piece and two curved ends.

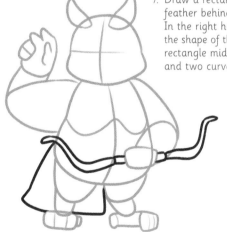

8. Add two solid circle eyes with a curve around the top and a diamond beak. Outline the face and ear tufts with fluffy edges. Lightly draw a dashed, round heart around the face.

ARCHER

(continued)

9. Sketch a hood on the head. Draw a crescent moon clasp at the neck and make the cape drape over the shoulders and flow down the back.

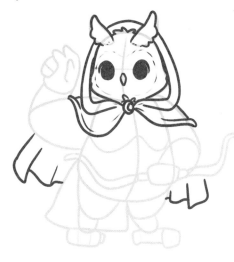

10. Add a strap crossing the body from left to right with a buckle in the center. Under the belt, draw a simple short-sleeved shirt with a split in the bottom.

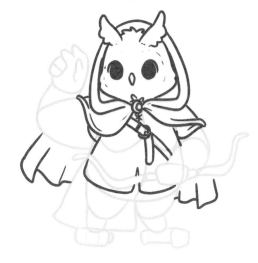

11. Outline the lower body and legs, adding fluffy texture. Add the feet but keep them smooth.

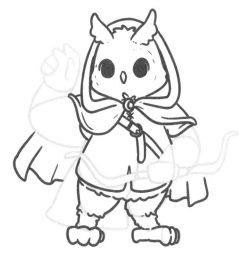

12. Detail the bow with a string between the two ends and some bows tied at the tips.

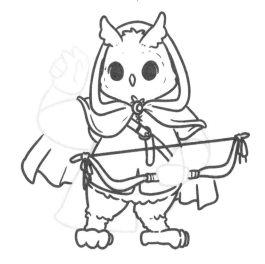

13. Draw the arms and hands, adding large, rounded feathers along the edge of the arm.

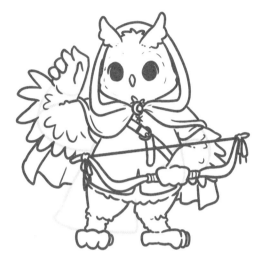

14. Between the two splayed fingers of the left hand, add the fletching of an arrow with more in a quiver behind the hand. Outline the tail with a feathered edge.

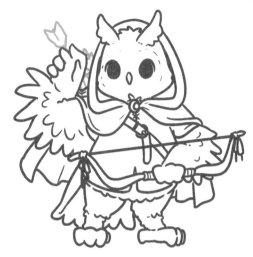

15. Neatly draw the line art over the sketch, then gently erase the sketch underneath. Add some dashes on the cheeks for blush, highlights in the eyes, and sparkles around the character if you'd like.

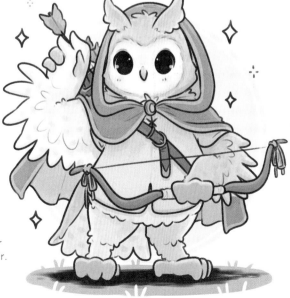

16. Let's color! I made my character a barn owl with the coloring of gold and white with pink feet. I used green for the cloak and shirt and light red for the arrows and quiver.

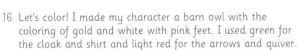

LEGIONNAIRE

A legionnaire that guards the hamlet, this wolf can be serious and a little grumpy, but they're a true team player and always happy to work with company. Find them with their armor always shined and swords sharpened. They will be able to smell a battle coming a mile away.

1. Draw a round shape for the head with a curve on the left for the snout. Add a little line across the face for a guideline.

2. On top of the head, draw two triangle ears.

3. Add a small U neck. Draw a soft W-shaped upper body with a long, curved guideline down the middle.

4. For the lower body, sketch a rectangle with a trapezoid under it. Divide the trapezoid into three smaller triangles with two diagonal lines for the hips.

5. Under the hips, sketch two long, thin Us for the thighs. Draw pointier Us for the lower legs. Then add the feet in two sections of a triangle and a rectangle. Angle the left foot to the left.

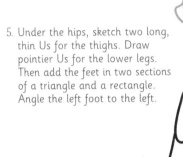

6. Sketch circles for the shoulders, then add the arms with a U and teardrop shape. Angle the arms so they're lifted off the body.

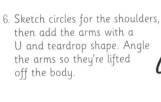

7. Add the right hand in a closed fist. Then draw the rough shape of a sword and its guard. In front of the left arm, draw the side of a shield with a tapered top.

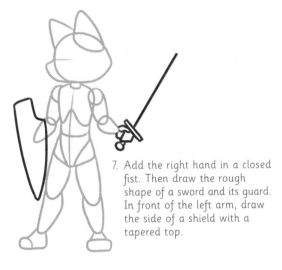

8. Start the tail on the right side of the body and curve it behind to the left with a pointed tip. On the face, add an eye with a line above, a triangle nose, and a mouth.

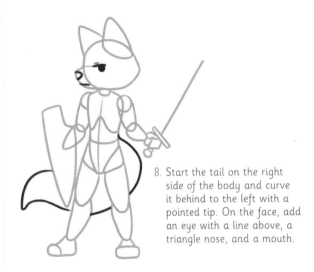

LEGIONNAIRE

(continued)

9. Outline the head and ears, adding fluffy edges. Add small dashes around the sides of the head for some whiskers.

10. Draw the shoulder pauldrons and chest plate with the collar of a doublet underneath. Add a knotted belt around the waist.

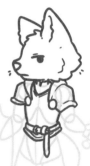

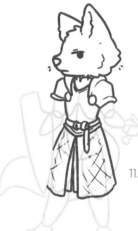

11. Draw the lower body padding with a diagonal grid for some texture. Make a split down the middle where you can see the doublet underneath.

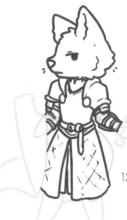

12. Add the arms with more armor. Draw straps holding the armor onto the arms.

13. Detail the shield with a
trim and the sword with
a pointed blade and a
guard with rounded ends.

14. Add some armor strapped
to the lower legs. Add the
feet with toe lines. Sketch
a cape flowing on the right
side of the body.

15. Neatly draw the line art over
the sketch, then gently erase the
sketch underneath. Add some
dashes on the cheeks for blush
and highlights in the eyes.

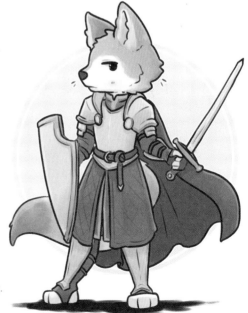

16. Lastly, add color! I chose gray with white
patches for the fur, dark teal for the cloak
and doublet, and gold for the armor. Then
I used brown for the straps, belt, and padding.

SORCERER

Rumor has it that this crow was once a necromancer's familiar, but over time, after a lot of magical exposure, he grew smart and gained magic of his own. Now he travels the world with some spooky spirit companions.

1. Draw a circle for the head with a curved triangle beak on the left. Where the top of the beak meets the head, add a guideline.

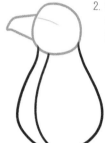

2. Under the head, draw a large egg-shaped body. Add a curved guideline down the middle.

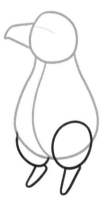

3. At the bottom of the body, add a circle for the right thigh with a partial circle for the left thigh. Attach two thin U shapes below.

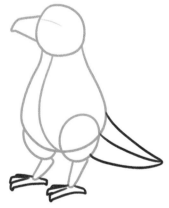

4. Draw the shape of the bird feet with three front talons and one back talon at the ends of the leg. Add a long triangle tail on the right with a line down the middle.

5. Add a curved wing on the left with a pointed "thumbs up" and the "fingers" wrapping around a straight line with a circle on top.

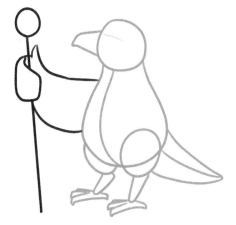

6. At the right shoulder, add the other wing tucked into the body using an arch for the upper arm and a circle for the forearm. Make the hand a rectangle fist.

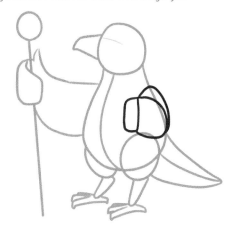

7. Above the tail, add the rough shape of a backpack with a cylinder on top. Add a bird skull on the flap with a circle and a triangle.

8. Above the crow, draw the rough shapes of a bird head and a cat head.

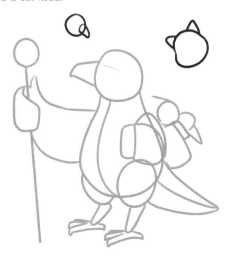

SORCERER

(continued)

9. Sketch a pointed hood with a tassel hanging off the tip and an eye-shaped clasp at the neck. Add a solid circle eye with a curve around the top and a curve for the mouth.

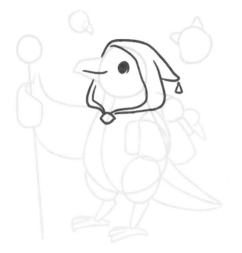

10. Outline the head and beak, adding fluffy edges at the chest and a little tuft at the top of the beak. Outline the wings, adding feathers along the middle and bottom.

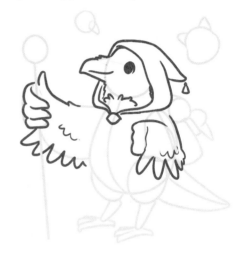

11. Add the straps of the backpack around the shoulders, then add more detail to the backpack, such as a spiral in the cylinder to make a bedroll and an eye socket on the bird skull.

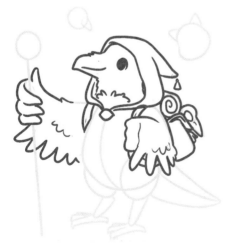

12. Sketch the front of the cloak with a split down the middle and a tattered bottom edge.

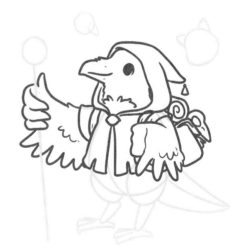

13. Under the cloak, add the bottom of a shirt with clasps down the middle. Add the legs and tail with feather detail. Then add the smooth lower legs and feet.

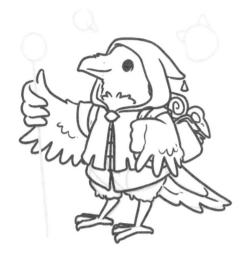

14. Detail the staff with three talons holding the orb and a pointed base. Make the bird and cat head floating spirits. Add faces but make their bodies a squiggly wisp, like smoke.

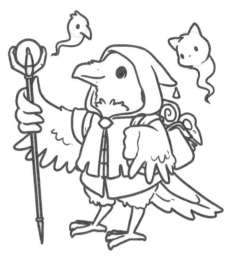

15. Neatly draw the line art over the sketch, then gently erase the sketch underneath. Add some dashes on the cheeks for blush, highlights in the eyes, and sparkles around the character if you'd like.

16. Add some color! I made the body a typical black crow and used shades of green for the cloak, shirt, and orb of the staff. The clasp is gold and the blanket is yellow. I made the ghosts white.

GUARDIAN

After traveling the outside world and getting into a few real battles, this lion is the self-elected chief guardian of The Wild Hamlet. He has a tendency to get carried away with his enthusiasm for his work, but his intentions are always for the safety of the hamlet.

1. Draw a round shape for the head with pointed sides and a plus sign guideline for the face.

2. Make a partial outline around the top and right side of the head. Add two small, curved ears on top. Draw a V under the head for the mane.

3. Draw a soft W-shaped upper body with a long, curved guideline down the middle.

4. For the lower body, sketch a rectangle. Then draw a triangle pointed down with two small upright triangles on either side for the hips. Angle the bottom slightly.

5. Under the hips, sketch two long, thin Us for the thighs. Draw pointier Us for the lower legs. Then add the feet with two rectangles. Make the left leg bend at the knee and both legs balancing on the toes.

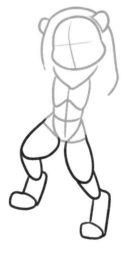

6. Sketch circles for the shoulders, then add the arms with a U and teardrop shape. Angle the left arm up and the right arm down and away from the body.

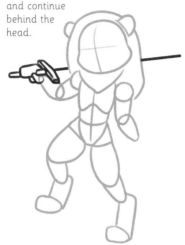

7. Add the left hand curved around the guard of a long sword. Make the sword's blade rest on the shoulder and continue behind the head.

8. Sketch a shield in front of the right arm with a curved plus sign guideline. Under the left foot, add a round shape for a rock.

9. Add two solid circle eyes with a curve around the top. Draw a large, rounded snout with a V-shaped nose and a curved mouth with pointy teeth and a tongue.

10. Add the mane around the head with two braids and a lot of fluffy texture. Add the ears.

GUARDIAN

(continued)

11. Draw a knotted belt around the waist, but leave some space between the belt and the body for the armor.

12. Add three pieces of armor under the belt, with two on the sides and one in front.

13. Sketch the shoulder pauldrons and chest plate.

14. Draw a skirt with a grid pattern and a piece of fabric hanging down between the legs. Sketch pointed armor on the knees and add the rest of the legs and feet.

15. Draw a tail starting just under the skirt on the right and wrap it behind the body to the left. End the tail in a fluffy tuft. Then add another piece of fabric hanging behind the legs and tail.

16. Draw the sleeves and armor around the wrists. Detail the left hand and sword, making it pointed at both ends.

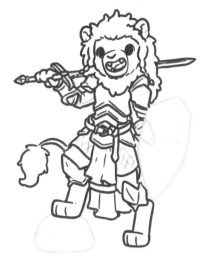

17. Detail the shield with a trim and add a few scuff marks and arrows stuck in it. Add some detail to the rock.

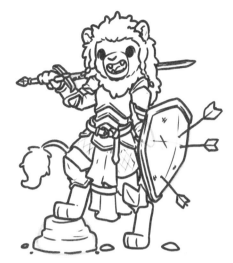

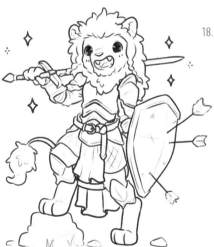

18. Neatly draw the line art over the sketch, then gently erase the sketch underneath. Add some dashes on the cheeks for blush, highlights in the eyes, and sparkles around the character if you'd like.

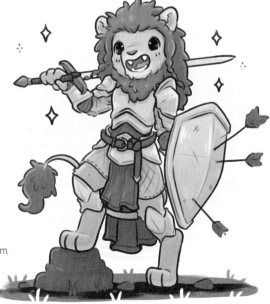

19. Finally, add color! I used a classic lion's coloring, with silver armor and a gold trim. I made the clothing shades of blue with red accents on the trim and for the arrows.

MAGICIAN

This dragon mage's greatest talent lies in pyromancy (fire magic). But he wishes to distance himself from his four-legged ancestors' more savage nature and has dedicated his life to mastering the arcane arts to become a great scholar.

1. Draw a round shape for the head and add a plus sign guideline. In the bottom half, draw a rounded rectangle for the snout.

2. On top of the head, draw two sets of horns: one set of thin triangles and one set of long, curving triangles. Add a small U for the neck.

3. For the body, draw a stretched egg shape. Add a W-shaped guideline for the upper torso, a curved guideline at the hips, and a long, curved guideline down the middle.

4. Draw ovals for the thighs, with the left one partially concealed behind the body. Then add the feet with a long rectangle and a small rectangle with toe lines.

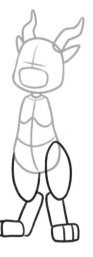

5. Draw circles for the shoulders, then add the arms with a U shape and a teardrop shape. Angle the left arm up and away from the body, and the right arm down and away from the body.

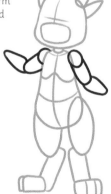

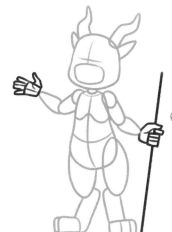

6. Sketch the hands. In the right hand, draw a long straight line. Make the left hand an open palm facing up.

7. At the top of the right thigh, start the tail. Curve it down and behind the body, with the end flicking up into a small arrowhead point.

8. Start the wings at the shoulders. Use a stretched Z shape with a line coming down from the top point.

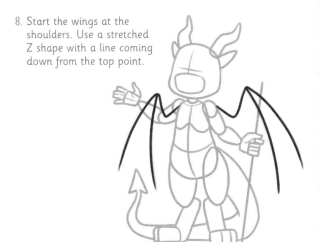

9. Draw the outline of the head and horns. Add some spikes around the head. Sketch two rings near the top of the longer horns.

MAGICIAN

(continued)

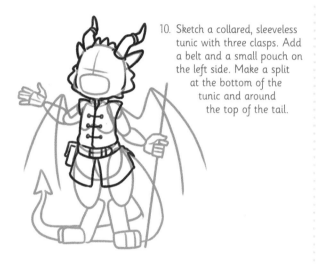

10. Sketch a collared, sleeveless tunic with three clasps. Add a belt and a small pouch on the left side. Make a split at the bottom of the tunic and around the top of the tail.

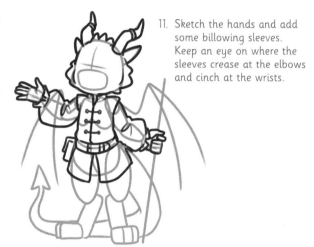

11. Sketch the hands and add some billowing sleeves. Keep an eye on where the sleeves crease at the elbows and cinch at the wrists.

12. In the right hand, detail the staff. Make the top a thin crescent shape with an oval floating within its curve. Draw a friendly flame hovering above the left hand.

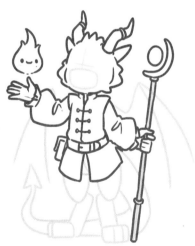

13. Sketch the legs and tail. Add some definition to the clawed toes and draw small spikes along the top of the tail.

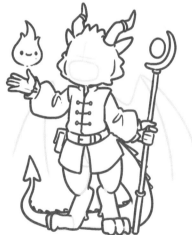

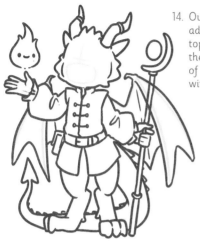

14. Outline the wings and add a spike at the topmost point. Join the bottom points of the wings together with a V curve.

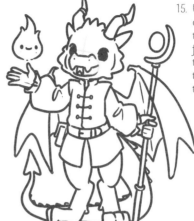

15. Using the guide of the snout, add two bumps on top for the nostrils and two V fangs along the middle. Draw two solid eyes with a curve around the top, dots for nostrils, and a forked tongue.

16. Neatly draw the line art over the sketch, then gently erase the sketch underneath. Add white and red highlights to the eyes and some sparkles around the character if you'd like. Don't forget some sparks around the flame!

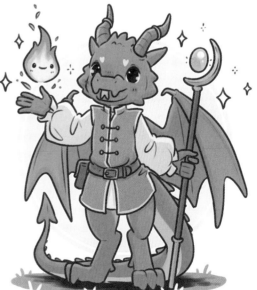

17. When adding color, pick whatever colors you'd like! I went with red scales and brown horns. I chose a bright blue jacket and a pale pink shirt with brown accessories, then added touches of orange in the flame and gem of the staff to represent fire magic. For the small details on the dragon mage, I used pale pink.

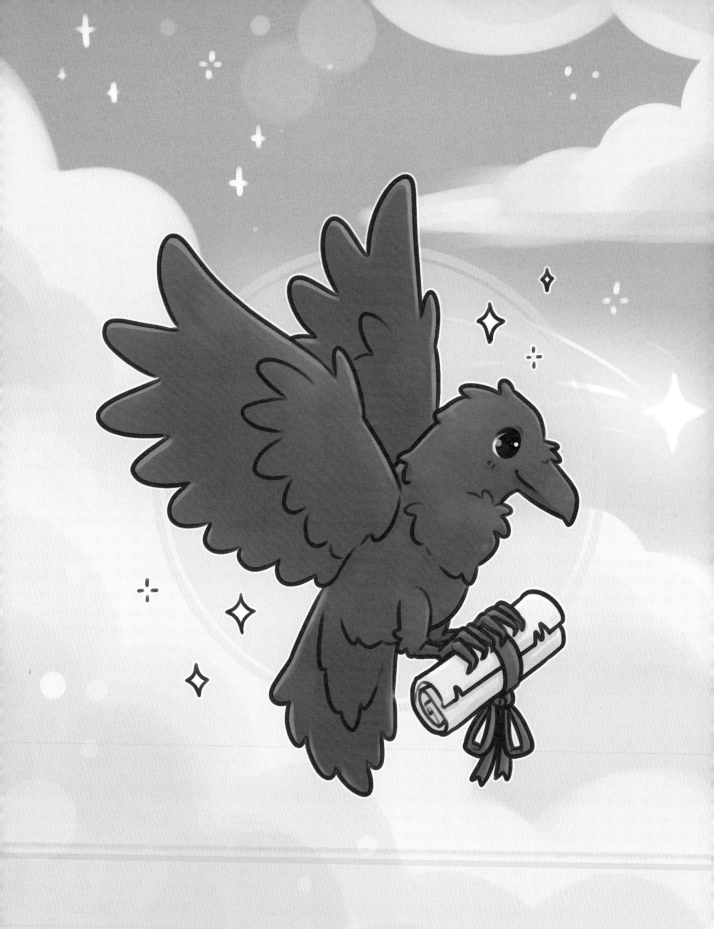

BONUS CHARACTER FAMILIARS

FROG

Sometimes an adventurer just needs a little friend. If your character wants a hopping, enthusiastic companion, this little frog is volunteering for the job!

1. Draw an oval for the head. Add two curves on top of the head for the eyes. Then add a guideline down the middle of the head.

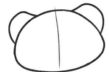

2. Add a U-shaped body under the head and continue the guideline down the middle.

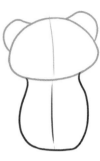

3. On the bottom sides of the body, draw two ovals angled outward for the legs. Add a curved line inside to divide the upper and lower leg.

4. Inside the body, draw two ovals for the arms. Sketch the hands as triangles.

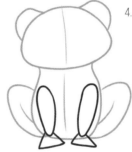

5. At the bottom of the legs, add semicircles for the feet.

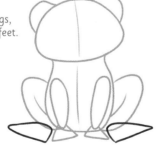

6. Add three small circles on each hand and foot.

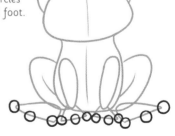

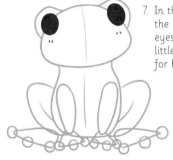

7. In the curves on top of the head, add solid circle eyes. Underneath, add two little dashes on the cheeks for blush.

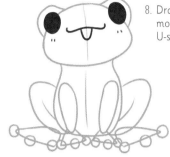

8. Draw a flat W for the mouth with a little U-shaped tongue.

9. Outline the body using the guidelines. Make sure to pay attention to where lines overlap.

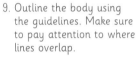
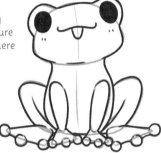

10. Neatly draw the line art over the sketch, then gently erase the sketch underneath. Add some dashes at the top of the face and red and white highlights in the eyes.

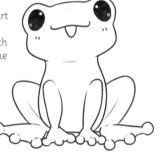

11. For color, I chose a classic green with a pale belly and pink for accents of the tongue, blush, and shading.

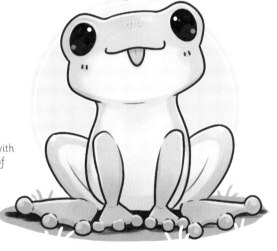

SNAKE

For characters who want a familiar of the slithery variety, a snake enjoys traveling while wrapped around the shoulders or arms.

1. Draw an oval for the head. On the right side, add a curve for the snout. Draw a plus sign guideline for the face centered above the snout.

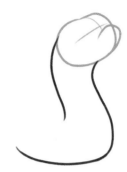

2. Sketch two parallel curving lines coming down from the top and bottom of the head. Make the right line curve over to the left for the bottom of the body.

3. Continue the bottom line up and over to the right. From the left line, draw a small U curve.

4. Add a backwards C shape on the right side of the body.

5. On the left side of the body, add the curving tip of the tail.

6. Add a partial wavy W shape for the mouth. Make a forked tongue coming out of the mouth.

7. Add two solid circle eyes with a curve around the top, keeping the right eye small as it is partially concealed. Add little dashes on the cheeks and above the snout.

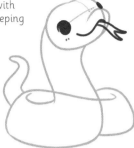

8. Outline the head, making a little dip on the top.

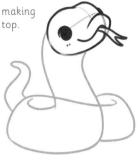

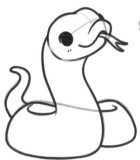

9. Outline the body. Keep an eye on where some lines overlap.

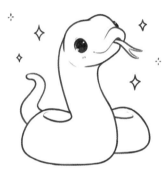

10. Neatly draw the line art over the sketch, then gently erase the sketch underneath. Add some highlights and hearts to the eyes and sparkles around the character if you'd like.

11. Time to color! I chose to make my snake a spotted green, but there are limitless snake colorings out there, or you can make up your own. Happy coloring!

CAT

For a magical character, nothing quite beats the classic familiar of a cat. They're great for helping with spells—and they're super fluffy and cute!

1. Draw a round shape with pointed sides for the head and add a plus sign guideline for the face.

2. On top of the head, draw two triangle ears. Add a line down the middle for the inner ears.

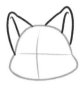

3. Under the head, add two rounded Vs for the neck and chest. Draw a curved guideline down the middle.

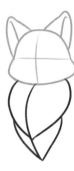

4. On the sides of the lower V, add ovals for the shoulders. Make the left shoulder partially hidden by the body. Draw two lines under each shoulder and add a rectangle paw at the bottom.

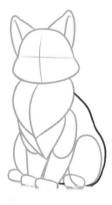

5. On the sides of the front legs, draw ovals for the back legs, with the left leg partially concealed. Add two rounded rectangle paws.

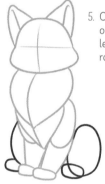

6. On the right side of the body, draw a line starting at the neck and curving underneath the right foot.

7. On the bottom right of the body, add a C shape to start the tail. Then curl the tail up from the left leg in an L shape.

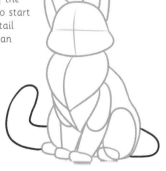

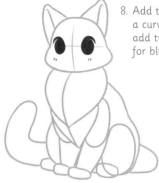

8. Add two solid circle eyes with a curve around the top. Then add two dashes on the cheeks for blush.

9. Draw a small triangle nose and a W shape for the mouth. Add a small U for the tongue.

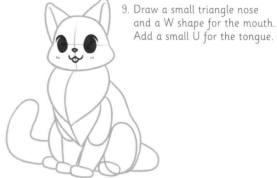

10. Draw whiskers around the sides of the face and a line above the nose. If you'd like a more magical look, add a little four-pointed star on the forehead.

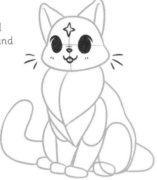

11. Outline the body, adding lots of fluffy detail and the toe lines.

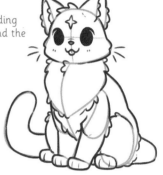

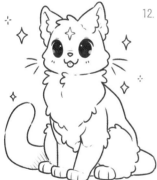

12. Neatly draw the line art over the sketch, then gently erase the sketch underneath. Add some highlights and hearts to the eyes and sparkles around the character if you'd like.

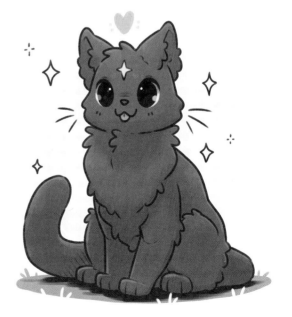

13. Add color! I chose a classic black cat for a more witchy look, with blue in the eyes, pink for the inner ears and tongue, and yellow for the stars.

OWL

Is your fantasy character wise and intellectual? If so, an owl is the perfect familiar for them. Place them on your character's shoulder or on the top of their staff so they can whisper information to your character.

1. Draw an oval shape with pointed sides for the head and add a plus sign guideline for the face.

2. On top of the head, add two semicircles for the ear tufts.

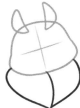

3. Under the head, add a rounded V shape for the chest. Sketch a curved guideline down the middle.

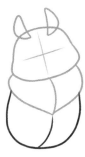

4. Add a large U for the body and continue the guideline down the middle.

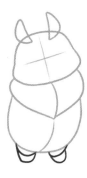

5. Under the body, add two small Us for the upper legs with two Us for the lower legs.

6. Draw two small ovals for the front toes, then draw a thin rectangle that goes under the toes for the perch. Add a third toe behind the perch.

7. Behind the left leg, draw a rounded triangle for the tail. On the sides of the body, add a curved line for the tucked-in wings.

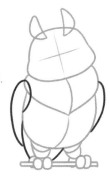

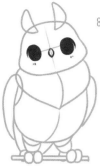

8. Add two solid circle eyes with a curve around the top. Then draw a diamond beak and dashes on the cheeks for blush.

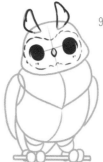

9. Add a dashed line around the face like a mask. Detail the ear tufts with some fluff.

10. Outline the rest of the head and body, adding some fluffy detail and feathered wings.

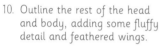
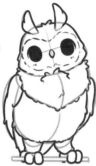

11. Detail the perch with cylinders on the ends and a pole underneath.

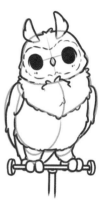

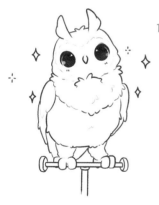

12. Neatly draw the line art over the sketch, then gently erase the sketch underneath. Add some highlights and hearts to the eyes and sparkles around the character if you'd like.

13. It's time to color! I chose a simple brown base and used a darker shade to add little flecks across the body, but you can color your owl however you like.

RAVEN

Perfect for a fantasy character that needs to send messages home while they're away! This raven's an expert at carrying notes across the land.

1. Draw a circle for the head. Add a pointed beak on the right. Then draw a guideline near where the top of the beak meets the head.

2. Draw a rounded V under the head for the chest. Then use a curved line to draw the body underneath.

3. Add the tail at the end of the body using a kite shape with a triangle inside.

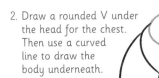

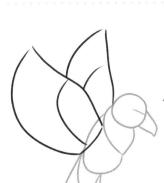

4. Sketch the rough shape of outstretched wings with two pointed ovals. Draw a curve in the bottom right corner of both wings.

5. To the right of the body, draw a cylinder with a rounded rectangle and a circle on the end.

6. On the bottom of the body, draw a small oval for the upper leg and a V shape for the lower leg. For the other leg, add a small U with a line pointing to the right.

7. Sketch the long toes wrapped around the cylinder, with three rectangles for each foot.

8. Add a solid circle eye with a curve around the top. Draw a curve extending to the bottom of the beak and little dashes on the cheek for blush.

9. Outline the head, body, legs, and tail with fluffy detail. Keep the lower legs and feet smooth.

10. Draw the wings, adding the curve of the feathers along the middle and bottom.

11. Detail the cylinder as a rolled-up scroll. Add a ribbon tied around the middle with a bow on the bottom. Draw a tattered edge and a spiral in the side.

12. Neatly draw the line art over the sketch, then gently erase the sketch underneath. Add some highlights and hearts to the eyes and sparkles around the character if you'd like.

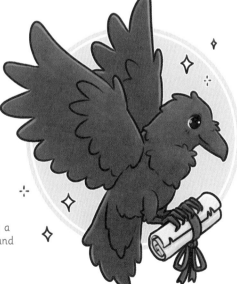

13. Lastly, add color! I made the body a bluish black with a red ribbon around the scroll for a pop of color.

FOX

Any adventurer would want this cute, fluffy fox friend traveling with them on their great quest. They're skilled in spying and obtaining pertinent evidence.

1. Draw a round shape with pointed sides for the head and add a plus sign guideline for the face. In the middle of the face, add a small, rounded square for the snout.

2. Add two large triangle ears on top of the head. Draw a curved line inside for the inner ears.

3. Add a rounded V neck with a curved guideline down the middle.

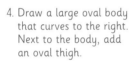

4. Draw a large oval body that curves to the right. Next to the body, add an oval thigh.

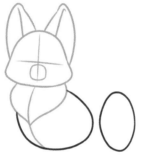

5. Join the two ovals together on the top and bottom with curved lines. On the bottom line, draw a U shape for the other leg.

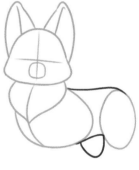

6. Under the neck, draw an oval for the right shoulder and a curve for the left shoulder that is hidden by the body. Then add a U shape for the legs.

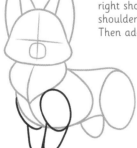

7. Slightly beneath the legs, add two small, rounded rectangles for the paws. Join the paws to the legs with lines.

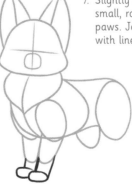

8. Under the thighs, add a U shape angled to the right. Then add the feet with a long, curved rectangle ending in a rectangular paw.

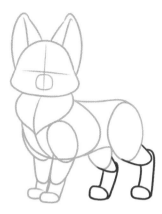

9. Start the tail at the top of the right thigh and curve it down and to the left, keeping it behind the legs.

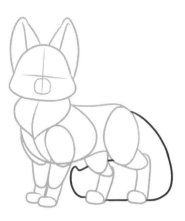

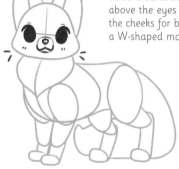

10. Add two solid circle eyes with a curve around the top. Add a small curve above the eyes and some dashes on the cheeks for blush. Add a nose, a W-shaped mouth, and whiskers.

11. Outline the head and body, adding fluffy details. Don't forget to draw the toe lines!

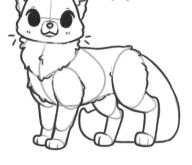

12. Neatly draw the line art over the sketch, then gently erase the sketch underneath. Add some highlights to the eyes and a heart around the character if you'd like.

13. Let's add color! I stuck with the classic orange fox with black legs and pink patches in the ears and on the face and chest. I used a darker pink for the blush and for shading.

BEAR

A big, strong companion that can climb trees, a bear familiar can be a great counterpart for your character.

1. Draw a rounded rectangle with pointed sides for the head and add a plus sign guideline for the face. On the bottom of the face, draw a rounded square snout.

2. Add semicircle ears on the top sides of the head. Then draw an oval starting under the left side of the snout and up to the right ear, making the bottom pointed.

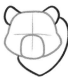

3. Draw a large curve on the right side of the body. Next to that, draw an oval for the thigh.

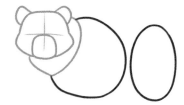

4. Join the body to the thigh on the top and bottom with curved lines. On the top right of the thigh, add a small, curved tail.

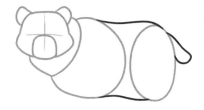

5. To the right of the neck, add a large oval for the upper leg and a U shape for the lower leg. Then draw a rounded paw.

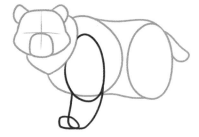

6. Next to the right leg, draw the left leg with a U shape and a thinner U underneath.

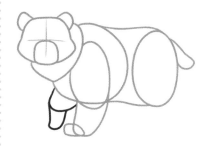

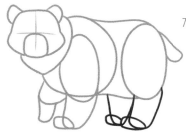

7. Under the thighs, draw two Us for the back legs and rounded rectangle paws.

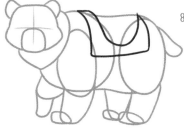

8. On the top of the back, draw a slightly curved rectangle for a saddle blanket, but do not draw the top line. Inside the blanket, draw a large U for the saddle.

9. Add two solid circle eyes with a curve around the top. Add a nose, a W-shaped mouth, and dashes on the cheeks and above the snout for blush.

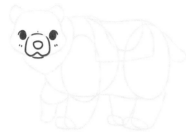

10. Sketch the shape of the saddle on the bear's back, adding two more Us and a curved top. Draw a raised handle at the front and detail the seat with a grid.

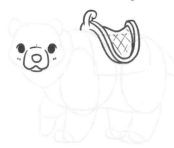

11. Add the saddle blanket with a buckle connecting it to the blanket. Add a strap from the bottom of the blanket that wraps under the body.

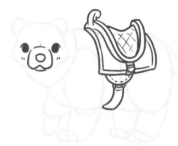

12. Outline the body with fluffy detail and add toe lines.

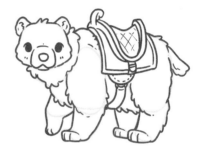

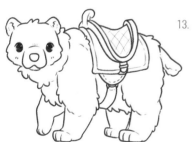

13. Neatly draw the line art over the sketch, then gently erase the sketch underneath. Add some highlights and hearts to the eyes.

14. Finally, add color! I chose to make a brown bear with a teal blanket and a blue saddle cushion. I gave the bear hearts for eyebrows and added a small heart above.

DOG

A classic companion for any traveling adventurer or tavern keeper, this dog is ready to support your character however they need, as long as treats and pets are frequently offered.

1. Draw a round shape with pointed sides for the head and add a plus sign guideline for the face. In the middle of the face, draw a rounded square snout.

2. On the top sides of the head, add triangular ears that fold over themselves.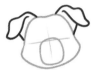

3. Add two rounded V shapes for the neck and chest, curving the chest to the left. Then add a curved guideline down the middle.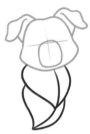

4. On the left, draw a curved line from the top of the neck to the tip of the chest. Next to that draw an oval for the thigh.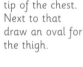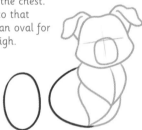

5. Join the body to the thigh with curved lines on the top and bottom. Then to the right of the thigh, draw a U shape for a second thigh.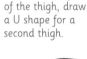

6. Under the thighs, add a small U shape. Then attach a rectangle foot and a rounded paw.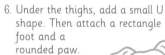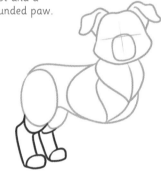

7. On the left side of the chest, draw an oval shoulder. Draw a partial right shoulder as it is hidden by the body. Then add a U for the arms.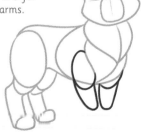

8. Sketch the paws below the arms with a rounded rectangle and connect them with lines.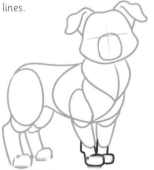

9. At the back of the body, draw a curled tail that tapers at the tip.

10. On each side of the body, sketch a 3D square pack with a square and two rectangles. Make sure that only the top of the second pack will be visible from this angle. Then add a curved cylinder on top of the back.

11. Add two solid circle eyes with a curve around the top. Draw a rounded nose and a W-shaped mouth with two fangs and a tongue sticking out. Add dashes for blush and whiskers.

12. Detail the packs with a flap and a bow. Add a strap around the middle of the cylinder and a spiral on the side. Add straps wrapping under the stomach and around the chest.

13. Outline the body, adding fluffy detail to the chest, legs, and tail.

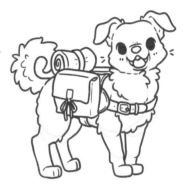

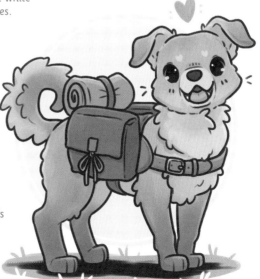

14. Neatly draw the line art over the sketch, then gently erase the sketch underneath. Add some red and white highlights and hearts to the eyes.

15. Finally, add color! I chose tan for the dog's coat, brown for the packs and straps, and blue for the bedroll and bow on the pack.

HORSE ✦

A fantasy character can only be complete with a trusty steed. In a magical land, there are many options for mounts, but nothing quite beats a classic and noble horse.

1. Draw a circle for the head with a small curve on the side for the snout. Add two teardrop shapes on top of the head for the ears.

2. Start the neck between the ears and under the chin. Curve the lines down and then to the left, making two distinct curves for the rear and chest of the body.

3. At the back of the body, draw a large oval thigh. Then draw two horizontal ovals below, getting smaller as you work down. Join the three ovals with curving lines and end with a triangle hoof.

4. Behind the leg, draw two more ovals and join them together for a second leg. Add a hoof at the end.

5. On the right side of the body, draw a medium-sized oval for the shoulder. Then draw two circles below, getting smaller and moving right and left as you work down. Join the ovals with curving lines and add a hoof.

6. Next to the front leg, draw a partial oval for a shoulder and a small circle for the ankle of the other front leg. Join the ovals together with lines and draw a hoof.

7. Add a fluffy mane, starting on the head between the ears and curving behind the left ear and down the neck. At the back of the body, sketch a long tail.

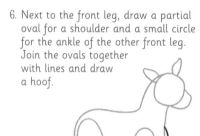

8. For the bridle, use lines to draw a strap around the snout, horizontally across the cheek, and in front of the ear. Draw a solid eye and a curved line around the top and add marks for the second eye, blush, and nostril.

9. Add the seat of the saddle with curved Us. Draw a curving shape on the side with two small semicircles on the edge. Attach straps that wrap around the front and under the stomach.

10. At the back of the saddle, draw a spiralled cylinder for a blanket. Add a square shape underneath for a small bag with a large side pocket.

11. Under the saddle, draw a large rectangle with a diagonal grid pattern for the saddle blanket. Then sketch a rectangle and a small bow for the clasp of the saddle bag.

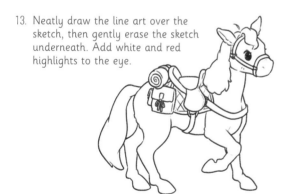

12. Lightly sketch the body, adding some small bumps for fur at the elbows and backs of the legs. Draw a short curve down the front of the chest.

13. Neatly draw the line art over the sketch, then gently erase the sketch underneath. Add white and red highlights to the eye.

14. Let's add color! I used a variation of browns, going darker for the mane, tail, and ends of the legs. The saddle seat is a soft red, the saddle blanket and bow on the bag is blue, and the rolled-up blanket is a light purple. I also placed a white diamond patch between the horse's eyes.

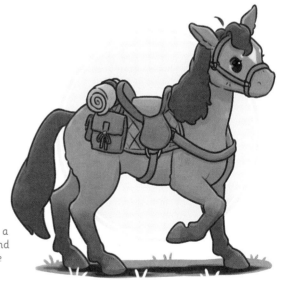

DRAGON

For the ultimate fantasy mount, give your character their very own dragon. Characters can soar the skies and use a dragon's mighty fire breath when fighting against enemies.

1. Draw a round shape for the head and add a plus sign guideline for the face. Add a rounded rectangle for the snout.

2. Add pointed curves on the sides of the head with two teardrop-shaped ears above. Between the ears, draw two curved horns that end in a point.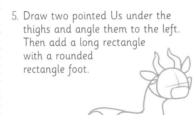

3. Draw two curved lines starting at the left ear and under the head. Join them on the left to make the neck. Next to the neck, add an oval for the thigh.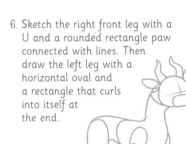

4. Join the thigh to the body at the top and bottom with curved lines. Add a U shape under the body for another thigh. Then add the shoulders with an oval, making the right one partially hidden.

5. Draw two pointed Us under the thighs and angle them to the left. Then add a long rectangle with a rounded rectangle foot.

6. Sketch the right front leg with a U and a rounded rectangle paw connected with lines. Then draw the left leg with a horizontal oval and a rectangle that curls into itself at the end.

7. Start the tail on the left of the back thigh. Use curved lines that overlap and twist up with the tip in an arrowpoint.

8. Sketch the rough shape of the dragon wings, starting at the curve in the neck. Use Z-shaped lines with two lines inside. Connect the points of the wings with a scalloped line.

9. Sketch a saddle with a grid-patterned seat. Make a curved knob for the handle and two straps around the neck and stomach.

10. Add two solid circle eyes with a curve around the top. Detail the snout with triangle bumps on the top and bottom and two dots for the nostrils. Add dashes for blush.

11. Outline the head and body, adding spikes along the sides of the head and down the back to the tail. Add fluffy detail to the cheeks, elbows, and knees. Make the toes have pointed tips.

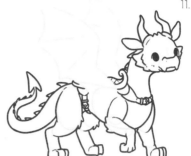

12. Draw the wings, adding detail such as a little hook at the top peak.

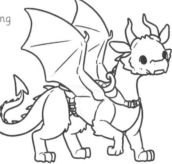

13. Draw a line along the bottom of the body from the neck to the tail for the underbelly and add horizontal lines inside.

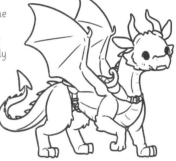

14. Neatly draw the line art over the sketch, then gently erase the sketch underneath. Add some highlights and hearts to the eyes.

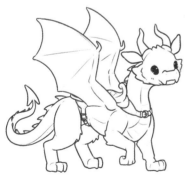

15. Add color! I made a classic red dragon with a paler color for the underbelly. For a pop of color, I used green for the seat of the saddle.

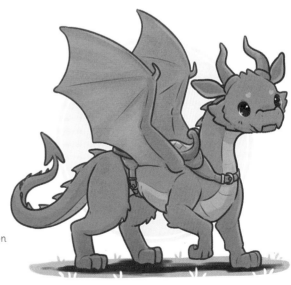

GRIFFIN

If your character needs to travel far distances in a short amount of time, a griffin familiar will be happy to fly them around and lend them an advantageous bird's eye view.

1. Draw a round shape with pointed sides for the head. Make it slightly tilted and add a plus sign guideline for the face. Add a rounded beak with a curved bottom.

2. Add two triangle ears on top of the head. Pay attention to where the right ear is hidden behind the head.

3. Draw a rounded V for the neck with a guideline down the middle that curves to the right.

4. To the right of the neck, add a large oval body. Next to it, add an oval for the thigh.

5. Join the body and thigh on the top and bottom with curved lines. Add a U shape under the body for a second thigh. Then draw an oval for the shoulders with the left shoulder partially hidden.

6. Under the shoulders, add a U with the left one angled to the left. Then add a rectangle with four toes for the feet. Place three toes along the bottom with the fourth higher on the right side of the foot.

7. Under the thighs, add a small U and a rectangle with a slight arch in the bottom. Then add a rounded paw.

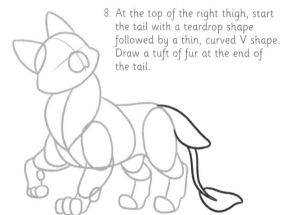

8. At the top of the right thigh, start the tail with a teardrop shape followed by a thin, curved V shape. Draw a tuft of fur at the end of the tail.

GRIFFIN ✦

(continued)

9. Start a wing at the top right of the neck. Use two Z-shaped lines that curve down. Detail the front wing with curved and diagonal lines.

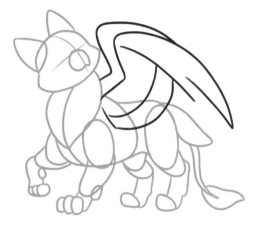

10. Add a curved rectangle on the back for the saddle blanket. At the base of the top wing, draw a curled handle of the saddle.

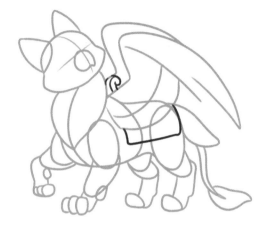

11. Add solid circle eyes with a curve around the top. Draw a pointed beak. Outline the head, ears, and neck, adding a lot of fluffy detail. Add dashes for blush and whiskers.

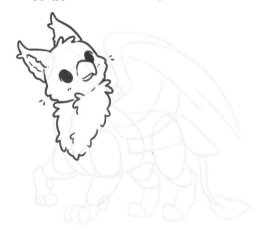

12. Outline the wings, adding feathers along the middle, underside, and at the tips.

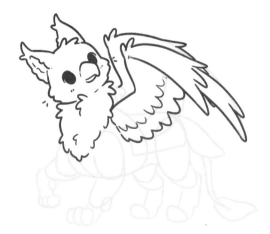

13. Sketch the saddle blanket and handle. Detail the saddle blanket with a grid pattern and add straps that wrap under the body.

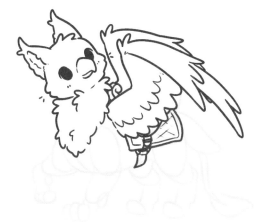

14. Outline the rest of the body with more fluff but leave the feet smooth. Make the front feet have pointed toes and add a tufted tail tip.

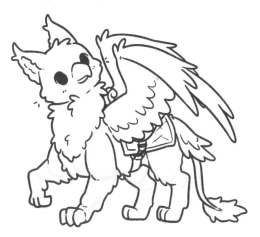

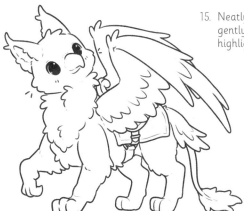

15. Neatly draw the line art over the sketch, then gently erase the sketch underneath. Add some highlights and hearts to the eyes.

16. Now add color! I chose gold for a classic griffin and darkened the top of the wing, the bottom of the legs and feet, and the end of the tail. I used pink for the inner ears and red for the blanket.

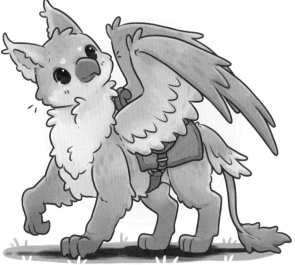

First published in 2025 by Rock Point, an imprint of The Quarto Group,
142 West 36th Street, 4th Floor, New York, NY 10018, USA
(212) 779-4972 www.Quarto.com

Rock Point titles are also available at discount for retail, wholesale, promotional, and bulk purchase.
For details, contact the Special Sales Manager by email at specialsales@quarto.com or by mail at
The Quarto Group, Attn: Special Sales Manager, 100 Cummings Center Suite 265D, Beverly, MA 01915 USA.

10 9 8 7 6 5 4 3 2 1

ISBN: 978-1-57715-453-2

Digital edition published in 2025
eISBN: 978-0-7603-9158-7

Library of Congress Control Number: 2024941285

Group Publisher: Rage Kindelsperger
Editorial Director: Erin Canning
Creative Director: Laura Drew
Managing Editor: Cara Donaldson
Editor: Katelynn Abraham
Cover Design: Beth Middleworth
Interior Design: Kim Winscher

Printed in China